Porcelain

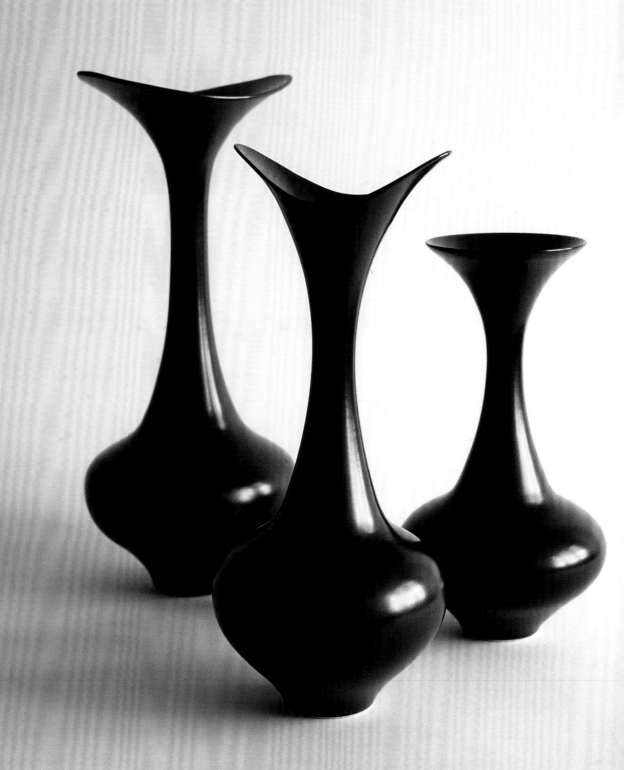

Porcelain

Vivienne Foley

B L O O M S B U R Y

LONDON • NEW DELHI • NEW YORK • SYDNEY

Bloomsbury Visual Arts
an imprint of Bloomsbury Publishing PLC

50 Bedford Square	1385 Broadway
London	New York
WC1B 3DP	NY 10018
UK	USA

www.bloomsbury.com

Bloomsbury is a registered trade mark of Bloomsbury Publishing PLC

Cataloguing-in-Publication Data
A catalogue record for this book is available from the British Library and the US
Library of Congress.

ISBN: PB: 978-1-4081-8464-6

Designed and typeset by Susan McIntyre
Printed and bound in China

FRONTISPIECE: Vivienne
Foley, classic vases. Black
magnesia glaze, tallest
44.5cm (17½in). *Photo: © VF*

CONTENTS PAGE: Chris Keenan
(UK), monochrome rocking
bowls, 2012. Tenmoku and
celadon glazes, reduction-
fired. H: 95mm (3¾in).
Photo: Michael Harvey

Contents

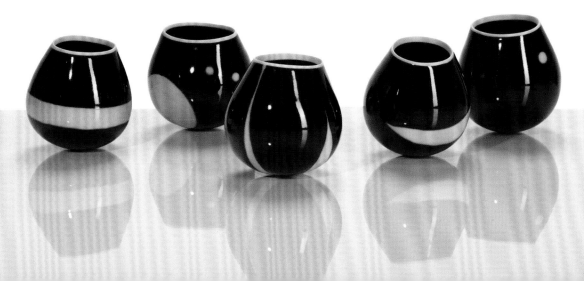

For Caroline and Madelyn

Acknowledgements

I would like to thank all those who helped me to produce this book, especially the 47 artists who have generously contributed inspirational images of their work.

Several experts in their various fields were unstinting in their enthusiasm and assistance in reading my text, sharing their expertise and pointing me in the right direction. My special thanks go to Professor Nigel Wood, FRSA, Dr Stacey Pierson, senior lecturer in Chinese Ceramics at SOAS, University of London, and Harry Fraser, F.I. Ceram, A.M.I.Ref. Eng. for their generous advice, and whose books have been my companions for years. Also Min Yin, Institute of Archaeology, University of London, Felicity Aylieff, Senior Lecturer, Royal College of Art, London, John Beeston and Becky Otter of Potclays Ltd, and Alan Ault of Valentine Clays Ltd.

Without Julia Sparks and Becky Foley's practical knowhow the manuscript might not have got very far, and, lastly, sincere thanks to my editor, Alison Stace, who was my anchor throughout the project.

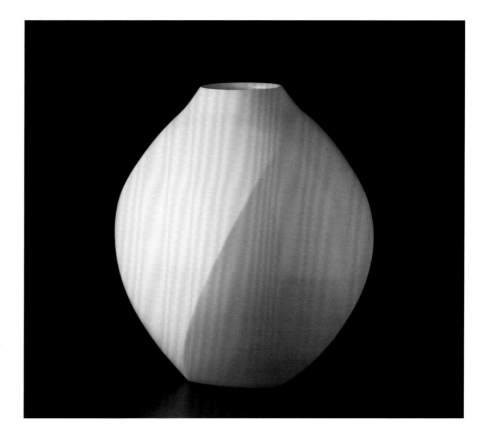

Akihiro Maeta (Japan), *White Porcelain Faceted Vase*, 2011. Faceted porcelain with glaze, H: 40cm (15¾in) x W: 35.3cm (14in). *Photo: courtesy of Yufuku Gallery, Tokyo.*

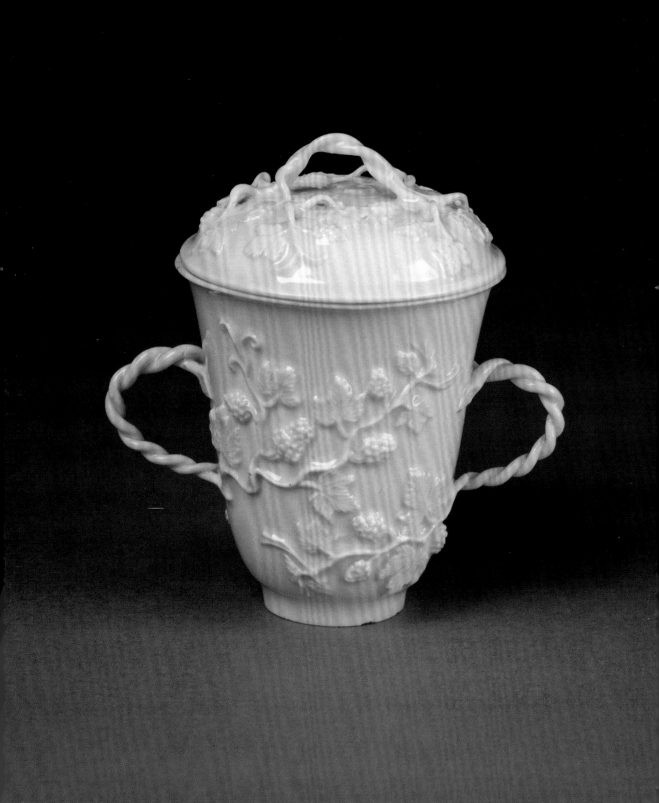

A brief history of porcelain

Augustus the Strong, despite claiming to be able to break horseshoes with his bare hands, had fine sensibilities when it came to porcelain. He was King of Poland and Elector of Saxony, a contradictory man of culture determined to make Dresden a centre for the arts, and determined to discover the secrets of making true porcelain. His breakthrough came in the year 1701 in the person of Johann Friedrich Böttger, a precocious young alchemist. Böttger, having escaped the clutches of gold-hungry King Frederick I of Prussia, was then detained for three years in a dungeon at the castle of Albrechtsburg near Meissen where Augustus likewise hoped to harness Böttger's alchemical talents. Under detention, Böttger's vain attempt to create gold from lead and mercury needed some explaining, but he cleverly allied himself to Count von Tschirnhaus, a noted physicist of the day. Together they conducted experiments initially on iron-rich clays and minerals from Saxony, which resulted, by the year 1708, in the discovery of true, hard-paste porcelain. Augustus, having at last secured the means of displaying his wealth and power, in 1710 founded the famous manufactory at Meissen, which is still in operation today.

Before this time the entire history of hard-paste porcelain belonged to the Far East, and it is there that we will find a story of more than two thousand years of innovation, skill, ingenuity and, above all, beauty. This is the story of porcelain wares, which have been traded across the world since the 10th century, and have had a major cultural and social impact on the development of civilisation.

CHINA

LEFT: Böttger, cup and cover, Meissen, 1715. Amongst the first hard-paste porcelains to be produced in Europe. Handles as twisted grape tendrils, with moulded and applied leaves and fruit, H: 11.8cm (4¾in).
Photo: © Victoria & Albert Museum, London.

The study of Chinese porcelain can be a lifetime's work, to be approached from many different perspectives. The ceramic types and forms, their utility whether for religious or secular purposes, their decoration including Taoist or Buddhist symbols or auspicious devices, their glazes and provenance, the wares made for Imperial use or for export to specific countries, all provide rich material for study. But first let us go back to the beginning.

Dating from the Shang Dynasty c.1700–1027 BCE, a 'proto-porcelain' vessel (a Western term) made from local porcelain stone has been excavated at the Huangfendui grave site in Zhejiang province, in an area where over 100 kiln sites have been found. The sophisticated cylindrical vessel that was found was clearly modelled on the bronze forms with which the dynasty is associated.

These and similar finds have in the past been viewed in a regional and social context but without specific data from kiln sites. Only recently has scientific analysis of glaze deposits on kiln walls and shards determined the chemical and physical properties

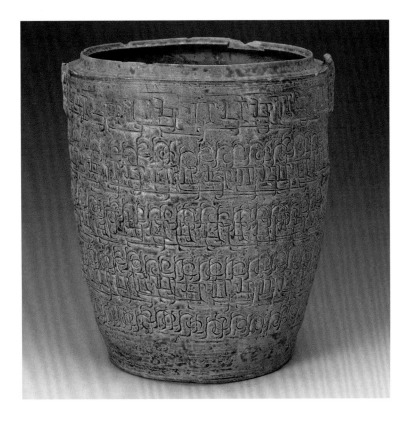

Proto-porcelain vessel, Zhejiang Province, Shang Dynasty 1700–1027 BCE. Photo courtesy of Zhu Jian Ming, Zhejiang Institute of Archaeology. First published in *Deqing Kilns: The Exploration of the Origin of Porcelain*.

of these early proto-porcelains, which helps us to understand the emergence of the lime-rich glazes. In northern China the development of white-firing clays and lime-rich glazes came to dominate later high-fired ceramics. The most interesting discovery is that even at this very early period kilns had been developed which were capable of reaching 1200°C (2192°F). This is the lowest temperature required for what we now categorise as true porcelain.

Archaic bronzes of the Shang dynasty made for ritual use (Gu, Zun, Ding, You) also influenced ceramic designs, which became remarkably consistent throughout subsequent eras, and can be found in monochromes and later as highly decorated wares. Similarly, the ceramics made for funerary and temple use, the tomb guardians, the models of figures and animals, in their turn all influenced later forms in porcelain.

Maps of China indicating kiln sites clearly show the main clusters of production are in the north and the south-east of the country. The development of high-fired porcelains depended on the geographical availability of materials and follows a north/south divide (see Chapter 2, pp.25–6). It took a slow evolution of 700 years for kiln technology and local skills to reach the point where pure white materials could be fired to temperatures high enough to produce a hard vitreous body. A few pieces of glass-like, true white translucent porcelain have been dated to the Sui-Tang transitional period of late 6th and early 7th centuries CE, though the subsequent Tang Dynasty wares, from 618 to 907 CE, are the first that we would recognise as porcelain today, not least because the sophistication and fineness of these pieces is so extraordinary.

Buddhism was brought from India to China during the Han dynasty (206 BCE–220 CE) and flourished in the 3rd and 4th centuries before declining in the 7th century. The consequent development and expansion of trade along the silk routes brought a wealth of ideas and materials to China which translated into ceramic form. Metalwork, jewellery and textiles from Iran and Central Asia all made a lasting impression on utility and style.

With Buddhism came tea (monks when fasting and praying through the long hours of night were still allowed to make tea), and many kilns specialised in the production of tea bowls.

During the Tang and Liao period (916–1125 CE), we encounter fine foliate bowls and phoenix-headed ewers showing that porcelain was developing into a fine art which continued to evolve through endless variety and inventiveness of form, glaze and decoration.

Song Dynasty

The Song Dynasty (960–1279 CE) is also categorised as northern and southern. The *ding* white wares produced in the northern *mantou* kilns were especially beautiful, later inspiring 18th-century copies which were nevertheless inferior in terms of forming and glaze.

Percival David Foundation no. 173, dish with trilobate form, China, Northern Song dynasty, ding type, 960–1050. Dia: 134mm (5¼in), H: 29mm (11½in). *Photo: © The Trustees of the British Museum, all rights reserved.*

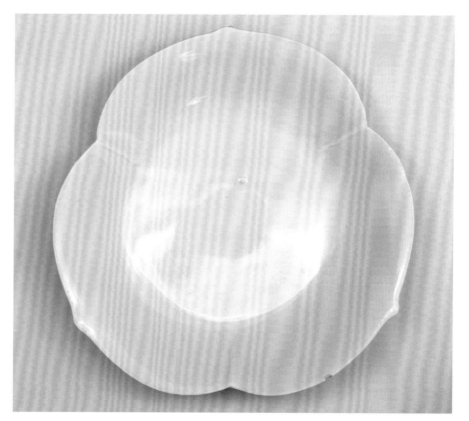

A very early lime-alkali porcelain glaze found in the south was the 10th-century Five Dynasties whiteware glaze made at Jingdezhen, the city which became the world centre of porcelain. A high limestone glaze with a jade-like appearance, it was followed by the *yingqing* or 'shadow-blue' glaze (also widely known as *qingbai*) a translucent lime glaze with traces of iron which gave very pale blue in reduction (see Chapter 6). Olive-green celadon wares were made in the north and the unctuous Longquan wares in the south. The wares, which developed from the Five Dynasties period onwards, are noted for their emphasis on form and beautiful monochrome glazes. They are perhaps the most beloved among ceramic artists today, though arguably more often with those working in stoneware, as they encounter fewer problems with body and glaze fit.

The first copper reds were developed on stonewares between the 9th and the 10th centuries in the isolated country kilns of Tongguan near Changsha in Hunan province. However, despite these wares being exported around the Far East, and even as far as East Africa and Egypt, the techniques remained local until they were reinvented and developed in the later Northern Song, Jun kilns, in the 11th century. The high period for copper-red glazes dates from the early 15th century when Jingdezhen porcelains were used for imperial rites. These glazes blossomed into the spectacular *fresh red* or *sacrificial red*, and in later periods *peach bloom* and *sang de boeuf*.

Yuan Dynasty

During the mid-14th century Yuan period (1279–1368), underglaze red was introduced in addition to underglaze cobalt. Wares were quite thickly potted in a variety of shapes echoing earlier traditions including stem cups, vases and censers. They were decorated with incised, carved and applied techniques including press-moulded beading. An excellent example to study is the *Fonthill Vase* (see p.17).

The Yuan Dynasty saw the introduction of the opaque white *shufu* glaze used on official wares at Jingdezhen.

Ming and Qing Dynasties

The Ming and Qing Dynasties date from 1368 to 1911. There were 17 reigns in the Ming Dynasty and 10 in the Qing Dynasty, and it is during this 600-year period that porcelain leaps into Western public consciousness, not least because this was the time when shiploads were arriving at European ports. In time, its popularity in Europe led to some underhand tactics. In 1712 a French Jesuit priest, Père d'Entrecolles who lived and worked in Jingdezhen, sent the first of two detailed and invaluable reports to Paris describing how the porcelain industry was organised. In today's terms he might be called an industrial spy.

The Ming Dynasty will forever be associated with blue and white. The imperial kilns of Jingdezhen during the Yongle (1403–1425), Xuande (1426–35) and Chenghua (1465–87) Dynasties produced porcelains of unrivalled quality, seen in the exquisite palace bowls with fluent cobalt-blue painting under a transparent glaze. The dragon kilns were carefully controlled and reached temperatures exceeding 1300°C (2372°F).

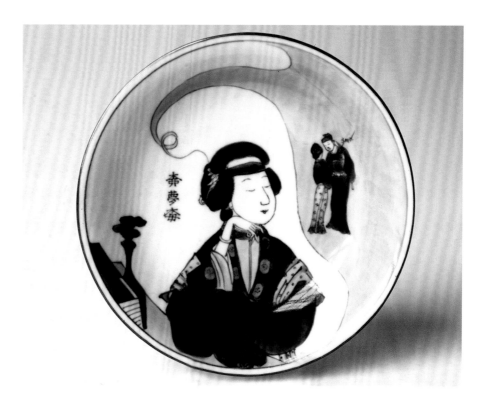

'Du Liniang Dreaming of Her Lover', (a story from the play *The Peony Pavilion*, which was first performed in 1598) Shunzhi Dynasty, 1650-1660. Dia: 16cm (6¼in). The Butler Family Collection, no.1414. *Photo: © VF.*

In the 14th and early 15th centuries expensive imported cobalt with a high iron content was used in addition to local cobalt with high manganese content. Later in the 15th and 16th centuries, imported cobalt was sometimes combined with local pigments, and after the 17th century local pigments alone were used, each giving recognisably different results that help us to date blue and white porcelains.

At first glance the blue can seem to be just a pattern, but close study reveals a fascinating and infinite variety of subject matter and meaning. The signs and symbols, such as the Taoist Emblems or the Eight Treasures, were all considered to be auspicious and can all be recognised in the paintings, as can symbols of luck or longevity such as the bat, the lingzhi fungus or the peach. Popular motifs such as the 'Three Friends of Winter' represented the ideal qualities of a gentleman, with pine, *prunus* and bamboo.

The symbol we most associate with China is the dragon, a motif depicted on ceramics since Neolithic times but perhaps most vividly portrayed on blue and white porcelain from the Yuan Dynasty onwards. The narrative scenes developed to a fine art in the 17th century were copied from popular texts of the period found on woodblock books and scrolls.

The removal of imperial control from the Jingdezhen kilns after the death of the emperor Wanli in 1620 contributed towards an economic boom. Despite the glaze problems of the 16th century known as mushikui (or worm-eaten) edges which persisted into the 17th century, export markets thrived as never before. The Qing Dynasty saw a proliferation of styles and many wares of outstanding quality but often, as the centuries progressed, with overcomplicated designs and painting. The overglaze enamel techniques, *doucai* (abutted colours) and *wucai* (five-colour), introduced in the

early Ming Dynasty, continued alongside the *famille verte* and *famille rose* painting styles which made the export wares so covetable. Visual puns or *rebus* were popular devices for decoration, especially in the overglaze glaze enamels of the Qing Dynasty.

Export trade

From 1405 to 1435 (under the Yongle and Xuande emperors), treasure ships of the great navigator Zheng He had taken cargoes of porcelain to the Middle East, Africa and, some say, the west coast of America. (In Persia in 1883 large Ming basins at the table of a local potentate were described by one European traveller as holding cones of ice cream as big as 'sugar loaves'). In fact, Chinese porcelains had been traded for centuries before the Europeans became established in the China trade, which flourished between the 17th and mid-19th centuries. The first to benefit were the Portuguese, who landed in Macao in 1514. Then in 1602 and 1604 two Portuguese carracks, or large merchant ships, were captured off Singapore by the Dutch, and thousands of pieces were sold off in Europe, thus beginning a stampede for a precious commodity which soon became the passion of kings.

The Portuguese traded between Indonesia and India, and were followed by the Dutch East India Company or VOC, who secured a trading post on Taiwan in 1624. The English East India Company first landed in Canton in 1637, but it was not until 1672 that they managed to secure trading rights in Taiwan, ten years after the Dutch had been expelled.

Today, through marine archaeology, we have a fascinating record of export from that

Dinner plate, Jingdezhen, 1750. Salvaged from the wreck of the *Geldermalsen*. Dia: 23cm (9in). Private collection. *Photo: © VF.*

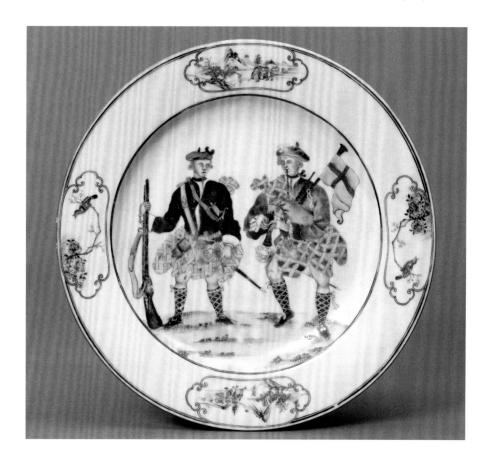

Jingdezhen export porcelain, made to order after an engraving by George Bickham depicting the heroes of the Jacobite Rising, 1743. On-glaze enamels, dish dia: 23cm (9in). *Photo: © Victoria & Albert Museum, London.*

period. Increasing numbers of shipwrecks are being investigated and their porcelain treasures brought to auction. A Dutch East Indiaman, the *Geldermalsen*, was wrecked in 1752 in the South China Sea; by 1985 there was very little left of the ship itself, but more than 150,000 pieces of porcelain lay on the ocean floor, in perfect condition. They were salvaged and finally, after 233 years, reached their destination – an auction house in Amsterdam.

From 1300 onwards the city of Jingdezhen worked flat out to supply the outside world with a commodity that could not be made anywhere else. Porcelain styles and modes of decoration were tailored to suit various markets. Bearing in mind that a dragon kiln could turn out 100,000 pieces in one firing, the quantities were staggering, especially as by the time of the Qing Dynasty these kilns had probably been replaced by still more productive egg-shaped kilns (see Chapter 7 for further details).

KOREA

Chinese ceramic technology and stylistic influence can be seen in Korea from the earliest times, but small quantities of porcelain were produced in the Koryŏ Dynasty (935–1392) alongside imported *ding* and *yingqing* wares. The main period of porcelain production was during the Chosŏn Dynasty (1392–1910), when Korean style is clearly recognisable.

Simpler shapes and a limited palette of underglaze colours were favoured above the flamboyant overglaze decoration and colour of Chinese wares, especially in the later period. The local cobalts gave a distinctive soft grey-blue, and copper reds gave a brick colour.

Porcelains were produced largely for the ruling elite, and there was never a thriving export trade. The iconic 'moon-jar' form, perhaps the best-known porcelain form from Korea, is still proudly produced by contemporary artists such as Park Young-Sook and Mun Pyung.

JAPAN

Until the final decades of the Ming Dynasty Chinese export wares named *ko-sometsuke* had satisfied the Japanese market. But with the discovery of porcelain stone at Arita in the early 17th century, the first Japanese porcelain manufactory was established, albeit with skilled Korean and Chinese immigrant labour. The Chinese potters who had fled the political disorder at the end of the Ming dynasty established a new standard at Arita, which gave the Dutch East India Company (VOC) the opportunity to exploit the kilns. Export trade to Europe and Asia flourished from the late 1650s to 1757 when Japan turned inwards and Arita supplied only the domestic market.

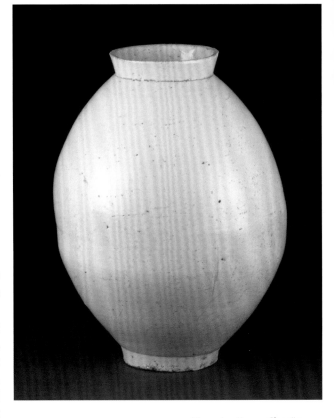

Moon jar, Korea, Chosŏn dynasty, made 1800-1900. H: 36 x D:12.3cm (14¼ x 4¾in). *Photo: © Victoria & Albert Museum, London.*

The rich native tradition of painting and textiles inevitably influenced porcelain decoration. *Imari* wares (shipped from the port of Imari) were made in several distinctively Japanese styles. *Kinrande* was painted with cobalt underglaze, red overglaze enamel, and, as gold was more available in Japan than China, a lavish use of gilding. More distinguished were the *kakiemon* wares with fluent overglaze painting in distinctive enamels. The 18th-century *kutani* wares were much imitated in the West, while the refined *nabeshima* wares were reserved for the Japanese aristocracy.

The export trade in porcelain declined due to the country's self-imposed isolation of the 17th and 18th centuries, but its re-emergence in the mid-19th century saw an explosion of interest in Japanese aesthetics in the West, a phenomenon known as Japonism.

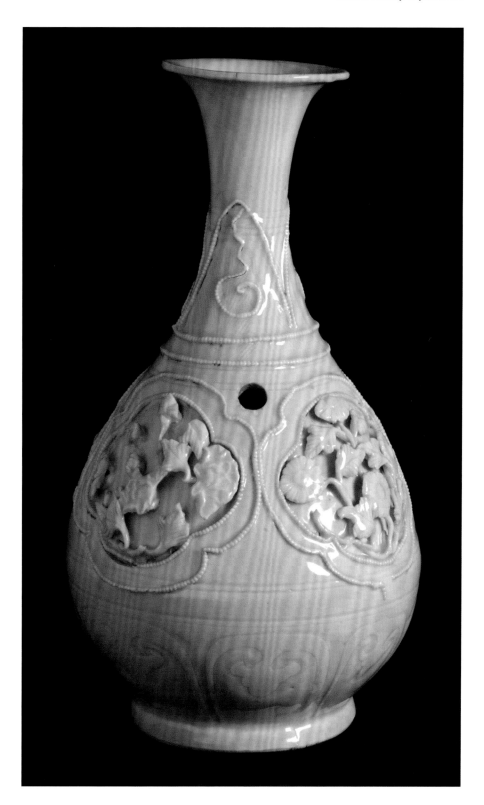

The Fonthill Vase, 1300–40 (Chinese Yuan Dynasty, 1279–1368). Made in Jingdezhen, this piece was the earliest documented porcelain object to reach Europe. Reputedly part of the collection of Louis the Great of Hungary, it was a gift from a Chinese embassy en route to visit Pope Benedict XII in 1338. The vase was later mounted with a silver handle and base, which were removed in the 19th century, hence the hole.
Photo: © This image is reproduced with the kind permission of the National Museum of Ireland, Dublin.

EUROPE

Although a few pieces of porcelain were reaching Europe from the 14th century onwards – the earliest documented piece to arrive on the Continent was the Fonthill Vase in 1338, now in the National Museum of Ireland – it was only from the 16th century onwards that we see these pieces arriving in substantial numbers.

In Venice, admiration for the blue and white wares and knowledge of Chinese porcelain in the collection of his ancestor, Lorenzo de' Medici, prompted Grand Duke Francesco I de' Medici to patronise Bernardo Buontalenti in his attempts to replicate the material. In 1575 he succeeded in producing a hybrid 'soft paste/hard paste' porcelain. Medici porcelain was recently analysed by Raman spectroscopy and found to be a compound of feldspar, calcium-rich glass frit, and sand, while the glaze indicated additions of calcined bones as an opacifier. Decoratively it was influenced by the native maiolica and also by shapes from silverware of the period. The invention was never commercial and very few pieces still survive. There was then a hiatus in the search for porcelain technology as Chinese imports flooded into Europe. The East India Company often packed the porcelain in chests of tea, thus fuelling twin passions amongst the upper classes, especially in England.

In France, towards the end of the 17th century, fresh efforts were made to create porcelain. Kaolin was still unknown in France but soft-paste porcelain had been made at Rouen in 1673 and by 1700 the Chicaneau family at St-Cloud under the protection of the Duc d'Orleans, brother of the King, had made their wares a commercial success that lasted until 1766. These porcelains, with their gilding and polychrome decoration, prepared the ground for the greatest saccharine extravaganzas ever seen. The porcelain room made for the Royal Villa at Portici near Naples in 1757 exemplifies these excesses. From 1763 to 1765 the Buen Retiro factory in Spain followed suit, producing soft-paste porcelain for a porcelain room at the Palace of Aranjuez.

Soft-paste porcelain continued to be produced in France under royal patronage up to the end of the 18th century at Chantilly and then Mennecy, from which point the style deviates from the oriental model into the full-blown Rococo style, with objects now encrusted with modelled flowers and sentimental figures to appeal to the aristocracy of the day.

The year 1756 saw the establishment of what became the preeminent French factory, at Sèvres, creating designs beloved of Madame de Pompadour with daffodil-yellow, pink and green grounds. This style was short-lived, however, giving way to a more restrained aesthetic after her death in 1764.

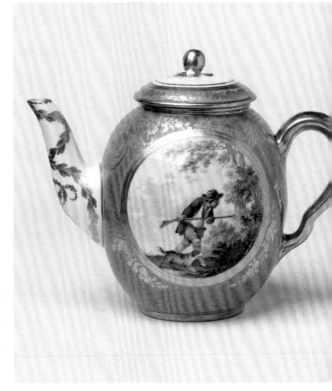

BELOW: Teapot with rose pompadour ground, Sèvres, 1775. Painted in enamels and gilt by Jean Bouchet, H: 16.2cm (6½in). *Photo: © Victoria & Albert Museum, London.*

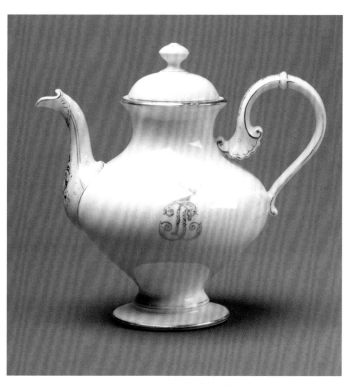

At last a French hard-paste porcelain was developed by Strasbourg faience maker Paul Hannong by importing kaolin from Germany. (Deposits of kaolin were later found at Limousin, which put Limoges on the map as a major porcelain-manufacturing city.) Thus the first successful porcelains were presented to the King in 1769.

After the French Revolution in 1789, the Sèvres factory became state-owned and in the 19th century soft paste was finally abandoned. Further development of porcelain in the Napoleonic era favoured the Empire style, which required highly skilled painting on plain grounds.

In Germany, as we have seen, Böttger's development of true hard-paste porcelain and his understanding of kiln technology was exploited to the full at Meissen, and by the mid-1700s 23 porcelain factories using the Meissen formula were operating in various German states.

ABOVE: **Coffee pot and cover, Sèvres, 1845–47.** Painted and gilded with the monogram of Louis Philippe as king. H: 16.2cm (6½in). *Photo: © Victoria & Albert Museum, London.*

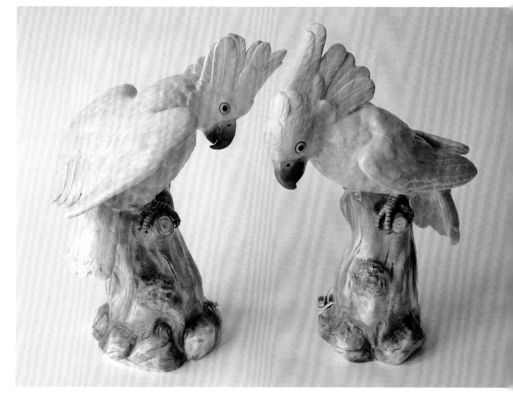

RIGHT: **Pair of parakeets, Meissen, late 1800s.** H: 26cm (10in). Private collection. *Photo: © VF.*

ENGLAND

In England patents for a porcelain-like material using calcined animal bones were taken out by Edward Heylyn and Thomas Frye in 1744 and 1749, at the time the Bow factory was established. In the following decades the Wedgwood, Spode and Minton factories were established at Stoke-on-Trent. At the turn of the century, the so-called 'bone china' was used in most English factories and was the main contribution to the development of the industry in England.

In spite of a steady supply of Chinese imports reaching the houses of the aristocracy from the beginning of 16th century, the earliest home-produced porcelain in 18th-century England was more influenced by European tastes from the factories of Meissen and Sèvres. Even so, the English style is recognisable especially in the charming soft-paste figurines produced at the foremost manufactory of Chelsea. One fine example from this factory is a Lowestoft jug of 1765 with on-glaze enamels showing a cricket match in progress. From the mid-18th century notable porcelain factories were also established at Bristol, Liverpool, Worcester and Derby.

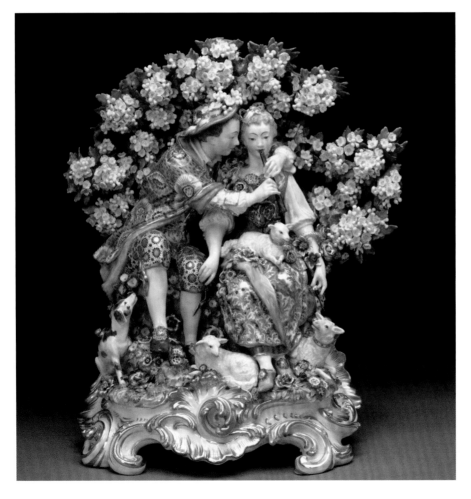

The Music Lesson, Chelsea, 1765. Soft-paste porcelain, painted enamels and gilt. H: 40.6cm (16in) x W: 27.9cm (11in). *Photo: © Victoria & Albert Museum, London.*

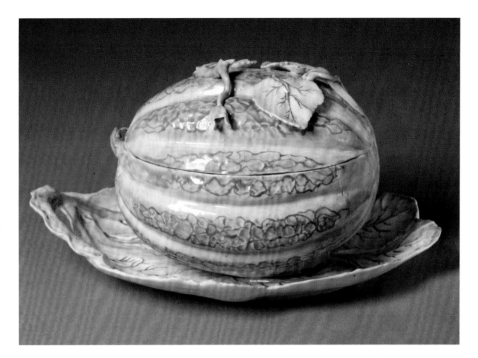

Sugar bowl and cover in the form of a melon, with stand, Longton Hall Porcelain Manufactory, Staffordshire, England, *c.*1755–60. Soft-paste porcelain painted with enamels. H: 14.9cm (5¾in) x L: 16.2cm (6½in); stand, L: 24.4 (9½in) x W: 17.8cm (7in). *Photo: © Victoria & Albert Museum, London.*

The independent discovery of true hard-paste porcelain was made in Cornwall by an apothecary named William Cookworthy. As early as 1745 he discovered that the essential materials, china clay and china stone, were present in abundance under his feet. However, it was not until many years later, in 1768, that he took out a patent, and even then production was beset by problems, so that in 1781 the shareholders sold out to a consortium of Staffordshire potters. It was from this point that the north Staffordshire region became the global centre for the production of porcelain until the late 20th century.

By the end of the 19th century the industrialisation of the potteries had all but extinguished the art of the individual potter in Europe. Gradually, however, France and Germany saw the beginnings of art pottery workshops where experimental glazes and ceramics under the influence of art nouveau or *Jugendstil*, its Germanic equivalent, began to emerge.

Across the Channel, the Arts and Crafts Movement was peculiarly English but exerted a significant influence on Western art values of the time. In the early 1860s Pre-Raphaelite painters including Rossetti, Burne-Jones and Ford Madox Brown collaborated with William Morris to promote the Gothic Revival in which artists and craftsmen worked together. They believed that industrialisation had impoverished society and they strove to bring back artisanal values with handmade furniture and textiles. In the case of ceramic artists, their high-fired wares were primarily utilitarian and almost exclusively stoneware.

During the interwar years of the 20th century one figure stands out as having pioneered studio pottery in England. Bernard Leach was born in China and lived and worked in Japan, where he was profoundly influenced by the Far Eastern aesthetic.

He set up his pottery in Cornwall in 1920 where he developed clays and glazes from local sources including a porcelain body. He was above all an effective publicist for the movement.

The other outstanding figure of the post-war years was Dame Lucie Rie, who came to London in 1939 as a refugee from Nazi-occupied Vienna. She was the exact opposite of Leach with her modernist background and entirely individual method of working. She continued to produce unique porcelains until her death in 1995 at the age of 93. Her work is still a major influence on those among today's ceramic artists who choose to work in, and expand the possibilities of, porcelain.

AMERICA

In 1784 the newly constituted United States of America took advantage of the political upheavals in Europe to search for its own trade routes to the Far East. From then on, trade between the United States and China strengthened, and between 1784 and 1844 no less than 520 voyages between the US and Guangzhou were made.

Porcelain was traded to America from the 1880s by Dublin émigré and ship-owner Benjamin Fuller. Specially ordered armorial services were painted with overglaze enamels in Canton on blanks made in Jingdezhen. Canton wares were hugely popular and often depicted sailing ships, which appealed to the merchant classes.

Although raw materials were to be found in America, skilled labour was not. A commercial venture founded in 1770 by Gousse Bonnin and George Antony Morris had lasted only two years. However, in 1825 the Quaker and enterprising amateur William Ellis Tucker of Philadelphia set about discovering how to make porcelain. The factory he founded was the first to supply the home market with a purely American product, though this was not without its challenges: after discovering an employee in the pay of English competitors was making sure all the handles fell off during the firings, they managed to stay in business until 1841 when cheap European imports took over.

In conclusion

More than a century and a half later the history of porcelain is not yet over. The porcelain of the 21st century is a high-tech material with unique properties. It has a low specific weight and is resistant to ultraviolet light. Its optical, electronic, acoustic and magnetic properties are of use in the aerospace, aviation, architectural and shipbuilding industries. Last but not least, the unique contribution of today's international ceramic artists continues to expand the possibilities of this extraordinarily beautiful material.

Wine pot with bamboo
form, Chinese, early Kangxi,
1662–75. H: 13.4cm (5¼in).
The founding piece in the
Butler Family Collection.
Photo: © VF.

THE GREAT COLLECTORS

The great collectors of Europe have been key to our understanding of the history of porcelain and our growing access to these collections continues to expand our understanding of the subject, both here and in the Far East. Whereas museum collections tend to be catholic, the collectors are more specialised, often concentrating on one particular era, allowing for more in-depth academic research.

Augustus the Strong (1670–1733), as we have seen, was so obsessed with collecting porcelain that not only did he stand down an army and swap 600 soldiers for 139 pieces of porcelain with the King of Prussia, but his collection of over 20,000 pieces (enough to fill his palace in Dresden) drove him on to develop the first true hard-paste porcelain and thus change the history of the subject forever.

Mary II of England (1662–94) was also a significant collector. As Queen to William of Orange she was in a position to take advantage of the vast quantities of porcelain being imported into the Netherlands by the Dutch East India Company.

In the 20th century, Dr Erika Pauls-Eisenbeiss (1910–73) and Dr Emil Pauls (1901–73) over a 20-year period collected porcelain from the four major German factories – Meissen, Höchst, Frankenthal and Ludwigsburg – and made a major contribution to scholarship. During the same period, two prominent Englishmen also accumulated outstanding collections. Sir Percival David, a businessman, scholar and collector, first visited the Forbidden City in Beijing in 1927, and began buying the ceramics which form the greatest collection (spanning the 10th to the 18th centuries) to be seen outside China or Taiwan. His foundation fostered the academic study of the subject, and some 1,700 objects are currently housed in a dedicated gallery in the British Museum.

The greatest collector of 17th-century Chinese porcelain of our time was undoubtedly Sir Michael Butler (1927–2013). After beginning his collection in 1959, during his career as a diplomat, he made a significant contribution to the understanding of the period by rescuing 17th-century porcelain from obscurity. It had long been assumed that after the Manchu invasions which ended the Ming Dynasty in 1644 and put a temporary end to the imperial kilns, the quality of the wares also declined. However, Sir Michael has demonstrated, through over fifty years of collecting, that the private kilns continued to innovate with extraordinary variety, skill and imagination to produce porcelains of outstanding quality and beauty.

NB: Some of the great world collections are listed in Appendix 1.

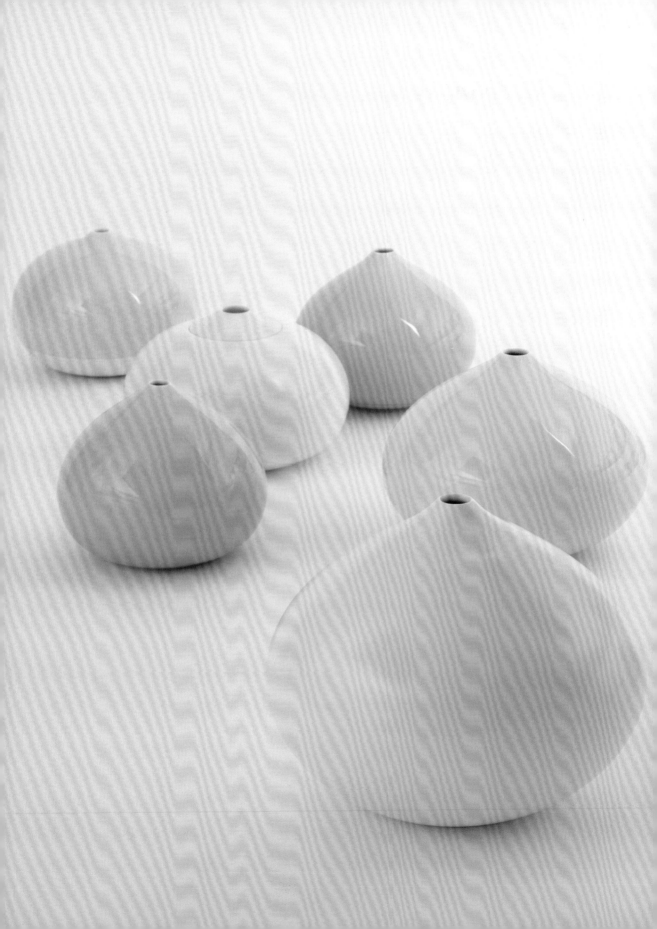

2

What is porcelain?

Porcelain is a white, fine-grained, manufactured clay, which is transformed when matured at temperatures of 1200–1400°C (2192–2552°F). In the following chapters we shall explore its defining properties and the exciting possibilities offered by this extraordinary material. It is made up of naturally occurring minerals, three in particular: china clay (kaolin), potash feldspar and quartz.

Granite is one of the commonest igneous rocks and forms a major part of the continental crust, but varies in its composition depending on its geographic location. It consists mainly of three minerals: feldspar, mica and quartz. These are essential elements needed for the construction of a porcelain body and local variations determine the character of the final ceramic product. It is an *intrusive* igneous rock formed from the crystallisation of magma pooling deep within the earth. Its slow cooling produces the large crystals of feldspar, mica and quartz evident in its structure. The subsequent decaying action of hot acid gases arising from the earth's core gradually converts the feldspar into kaolin.

Because the two main components (kaolin and quartz) needed for the production of porcelain are highly refractory, or (in the case of quartz) non-plastic, further small additions such as ball clay, bentonite or macaloid are necessary to produce a workable porcelain body. These additions, which include small percentages of iron, necessarily compromise the whiteness of made-up porcelains, and also increase the shrinkage, which helps to explain some of the main challenges experienced by ceramic artists.

The differences between high-fired stonewares and porcelains are small. Stonewares are also sometimes pale in colour, while both materials are dense and vitreous and mature in the kiln at temperatures over 1200°C (2192°F). However, porcelain has several outstanding qualities that have made it, throughout its history, a very attractive material for artists and have also ensured its continuing importance for the diverse ceramics industries.

Porcelain is valued by makers for its whiteness, its smooth texture and its translucency where walls and edges are thin. As we shall see, there is a fine line to be drawn between the qualities which makers actually want in their porcelain bodies and those which render it practical and workable. Ball clays and bentonite have an iron presence which can make a clay slightly darker and verge towards stoneware, and in fact many of these clays should be described as porcellaneous stoneware.

The kaolin seams in northern China from which the earliest porcelains were made in the early 7th century were sedimentary in origin, having been laid down in the Permo-Carboniferous period at the same time as the adjacent coal seams were being formed. They were clay-rich but unusually low in iron and often included natural fluxes, making them a complete material when fired to a high temperature.

LEFT: Lee Ka Jin (Korea), *Waterdrop* series, 2012. Thrown, reduction-fired to 1280°C (2336°F), dimensions variable (approx. 33 x 33 x 25cm (13 x 13 x 10in). *Photo: courtesy of Gallery LVS, Seoul.*

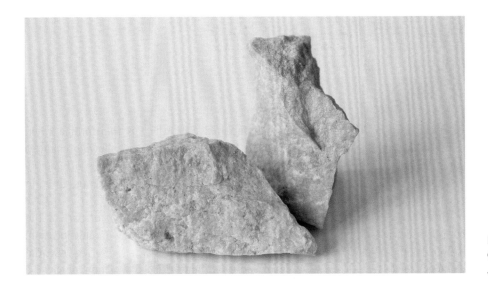

Porcelain stone from
Gaoling mountain near
Jingdezhen. *Photo: © VF.*

The southern Chinese porcelain bodies produced from the 10th century were quite different from those of the north and more akin to the stonewares that were already being produced in the region, being based on weathered rocks rather than sedimentary clays.

Kaolin was mined at Gaoling Mountain, a site north of Jingdezhen in Jiangxi province. Porcelain stone was found further south at Sanbao. It was comprised of quartz, the flux hydromica, and primary clays which were low in iron (containing approx. 0.6%) with only minor amounts of soda feldspar. The fired wares were white and translucent. This weathered and decomposed quartz/mica porcelain rock was known as petuntse. It was usable after being processed. The site was mined in open-cast quarries where the stone was crushed by water-driven trip hammers and delivered to the pottery workshops of Jingdezhen in manageable bricks. This site powered a revolution in ceramic production and generated exports to the world for 700 years.

Like the Chinese kaolins from Gaoling, those mined in the West are primary clays. These materials from which porcelains are made have been formed on the site of their parent rocks and have been eroded over millennia mainly by the action of groundwater seeping through them. These clays are fairly rare and are found in pockets accessible from the surface, making recovery by open-cast mining relatively easy.

This contrasts with so-called secondary clays. These clays, such as stoneware or earthenware (red clay), are composed of many different elements having also been subject to the geologic weathering of rocks over millions of years. They have been transported by wind and water and have collected many impurities, such as iron and carbonaceous material, along the way. They are found in huge deposits in river beds and estuaries all over the globe and can be mined at source. After the necessary cleaning and grading to remove organic matter and stones, they can then be used just as they come out of the ground for the manufacture of ceramics.

The chemical composition of clay is therefore very similar to the average composition of the earth's surface as a whole.

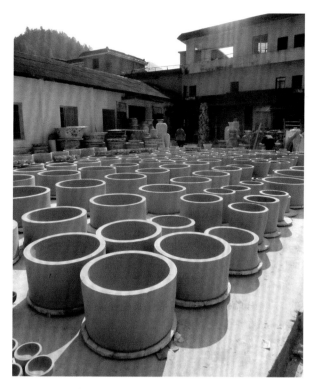

Production of large-scale porcelain in present-day Jingdezhen, China, where there are now international residencies avaliable for ceramicists.

Throwing as a team in a pottery, Jingdezhen, China.
Photos: by Felicity Aylieff.

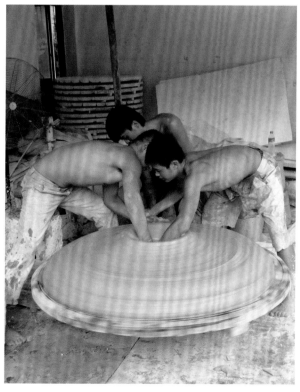

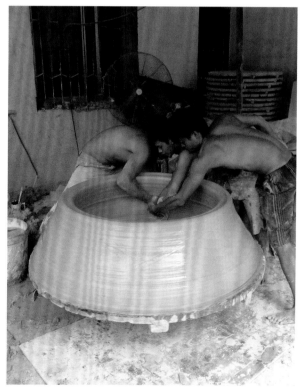

PORCELAIN: THE PRIMARY CONSTITUENTS, THEIR ORIGINS AND GEOLOGICAL MAKEUP

In order to understand their function in porcelain bodies it is of interest to review and take a closer look at the primary materials and their origins.

China clay (kaolin) (Al_2O_3 $2SiO_2$ $2H_2O$)

- China clay (kaolin) is a primary clay formed on site from the feldspar present in the original granite rock, as a result of geological weathering. Typically, these deposits were formed in the hot moist conditions of rainforest regions during the Cretaceous period 100 million years ago.

- Kaolin was formed by a complex sequence of events. While the molten rock was still cooling it was attacked by steam, boron, fluorine and tin vapour, all of which acted on the feldspar's alkali content and transformed it into kaolin.

- Kaolin is a layered silicate mined and processed in many countries worldwide. The colour, depending on the purity of the seam, can vary from pink to pure white.

- Kaolins are processed to remove naturally existing materials such as quartz, iron and titanium oxides, and organic matter.

- The largest and purest kaolin deposits in the world are found in Cornwall in the UK. They were discovered at Wheal Martyn in 1746. Since then 120 million tons have been extracted, with reserves expected to last for another 100 years.

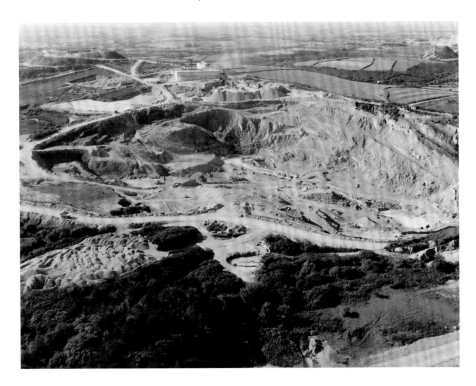

Wheal Martyn clay pit, Cornwall, UK. *Photo: courtesy of Wheal Martyn China Clay Country Park.*

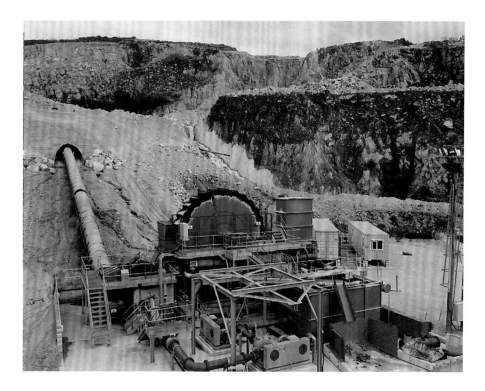

Wheel bucket, Wheal Martyn clay pit, Cornwall, UK. *Photo: courtesy of Wheal Martyn China Clay Country Park.*

- By the early 19th century the British kaolin industry had become big business. By 1910 production was a million tons a year with 75% being exported to the USA.

- Today 80% of kaolin is used for the paper industry for coating papers, and 12% for ceramics, with the remainder used in a wide variety of applications from paint to cosmetics.

It is interesting to see where the biggest producers are and how the kaolins vary. The major international producers are as follows:

America: The main kaolin deposits are found in Georgia, North Carolina and Florida. The so-called kaolin belt in the state of Georgia is the main clay producer in the USA and is a world leader in the manufacture of china-clay products. The deposits contain small amounts of rutile, which make the colour somewhat darker than English kaolin.

Florida EPK is a unique high-quality water-washed kaolin. Unusually, it was deposited as a sedimentary clay in an alluvial environment. It is of fine particle size and has a high green strength. It is considered somewhat more plastic than other kaolins and fires to a clean creamy colour. It has good casting properties.

The Czech Republic has extensive Carboniferous age sedimentary deposits and is the third largest producer of kaolin in the world. One of the outstanding kaolins is the Zettlitz kaolin from Karlsbad, which historically was used by many of the famous European porcelain factories but is now utilised mainly by the German insulator industry.

France: Kaolin mined in France is used for Sèvres and Limoges porcelains.

Australia: Kaolin deposits in North Queensland and Southwest Australia are currently being commercially exploited.

New Zealand: The kaolin deposits mined at Matauri Bay in the north of New Zealand are of volcanic origin and are claimed to be the whitest in the world. They produce porcelains and bone china of outstanding strength and translucency.

Feldspar potash ($K_2O\ Al_2O_3\ 6SiO_2$); Soda feldspar ($Na_2O\ Al_2O_3\ 6SiO_2$)

- Feldspars are the commonest minerals on earth and the major constituent of igneous and metamorphic rocks. They have varied composition but all have a similar crystalline structure.
- The feldspars found in granite can be a silicate of alumina, with potash, soda or lime in concentrations of as much as 60% of the parent rock.
- Feldspars contain enough elements to make a glaze, containing, as they do, potash (as a flux) and silica.
- Potash feldspar, or orthoclase, forms one group and is the commonest flux used for porcelain bodies; soda feldspar, or albite, forms the other group. These are the two materials most used by makers.

There are major deposits in the USA, Canada and Scandinavia, and small deposits in the UK and Scotland.

Quartz (SiO_2)

- Quartz is a crystalline mineral and a primary component of granite and other igneous metamorphic and sedimentary rocks such as sandstone and shale.
- About 70% of the entire land mass of the world contains silicon-bearing rocks. They vary tremendously between extremes of hardness like garnet to very soft substances like asbestos.
- Quartz's hard structure is resistant to weathering. It is strongly associated with gemstones since its microcrystalline varieties give rise to numerous semi-precious materials such as amethyst. In the ceramics industry quartz provides silica for clays and glazes. Due to its sharp crystalline structure it is considered hazardous in powder form.

THE PLASTICISERS NECESSARY FOR PORCELAIN BODIES

Ball clay

Ball clays are secondary or sedimentary clays which have been transported from their site of origin mainly by the action of water. They are commonly found in ancient lake beds in the UK and contain impurities such as titanium and iron along with carbonaceous material. They have an extremely fine particle size which makes them very plastic.

Bentonite (Al_2O_3 $4SiO_2$ H_2O)

Bentonite is formed from the weathering of volcanic ash, usually by the action of water. It is an extremely absorbent aluminium phyllosilicate, an impure clay consisting largely of montmorillonite, and has many industrial uses. Because of its propensity to swell, it is a useful sealant in the process of the disposal of spent nuclear fuel, while its excellent colloidal properties make it useful as a lubricant in the oil and gas industries. It is the main ingredient in fuller's earth, an industrial cleaning agent. A whiter calcium bentonite, which was formed by the action of seawater, is found in the Mediterranean region and has proved itself useful in the manufacture of the David Leach porcelain body.

Macaloid (CaO MgO Na_2O TiO_2 Al_2O_3 SiO_2 Fe_2O_3 SO_4 LOI)

Macaloid is specifically composed of 90% hectorite, originating with volcanic ash in the prehistoric Cretaceous period. It is a soft, greasy clay mineral.

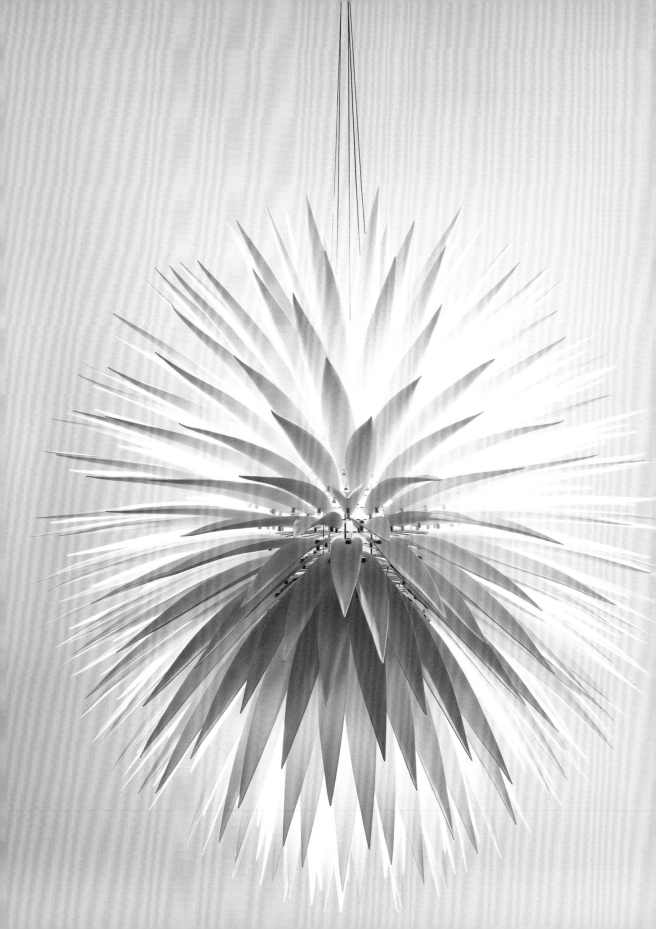

3

Producing a workable porcelain body

When I first started to throw with porcelain in 1965 there was virtually no choice in commercially available prepared bodies. I used Potclays 1146 until 2001 when it went out of production. It was an electrical body, containing steatite, which was used in industry to make insulators. Although very plastic and strong to throw, it was not translucent. Translucent bodies were, however, available, notably the David Leach porcelain body, based on Grolleg china clay and marketed by Podmore & Sons from the mid-1960s onwards. Then, in the 1970s, Harry Fraser developed his own porcelain body, also very plastic and translucent, which was later put into production by Potclays Ltd.

Nowadays the major UK suppliers manufacture an extensive range of porcelains catering for most requirements. The porcelain bodies produced in the UK generally mature at 1240–1280°C (2264–2336°F), whereas European bodies mature at 1300°C (2372°F).

The challenge for the maker is always which should come first: designing the glaze to fit the body, or the other way round? I think the former is easier, taking the firing temperature to be the first consideration (see Chapter 6, Glaze fit, p.116).

It is desirable to experiment with different commercial bodies and even to combine bodies to suit individual requirements. For any individual body, the manufacturer will supply specific details of shrinkage, absorption and thermal expansion, hardness, texture and firing range, as well as its suitability for reduction or oxidation.

Historically, porcelain was always considered an unsuitable material for handbuilding because of its propensity to crack when sections were thick or uneven, but now, as we shall see with the advent of paper clays, it has become an exciting medium for sculptural work.

Porcelain bodies must be fit for purpose and should be constituted as a throwing body, one for sculpture or one for slipcasting, the latter being more common in commercial production. The artist must make the choice.

To begin with, it is important to determine which qualities are most needed in the construction of a porcelain body. An artist working on a small scale might value translucency most. Someone producing large-scale thrown works may not consider this necessary. Inevitably, a body that performs well as a throwing clay must be made plastic with iron-bearing additions. Most makers require porcelain to be iron-free to the greatest extent possible, but extreme whiteness can often be achieved only at the expense of plasticity. An exception is the Australian commercial body LB Southern Ice, which has gained plaudits for extreme whiteness plus good throwing qualities, while some manufacturers claim to be able to source bentonite and plasticisers with very low iron content.

LEFT: Jeremy Cole (New Zealand), *White Flax*, 2008. Slipcast, LED lighting, 95 x 90cm (37½ x 35½in). *Photo: courtesy of Jeremy Cole Lightware NZ Ltd.*

Plasticity may not be so necessary in slipcasting. The large particle size in kaolin is an advantage regarding the rate of water absorption in the plaster mould.

CHOOSING THE MATERIALS: THEIR FUNCTION IN A PORCELAIN BODY

It is entirely possible to mix your own porcelain body as described later in this chapter. However, it is a big investment in terms of time, effort and materials given that there is such an excellent choice of commercially available bodies to choose from. It is much easier to experiment with these clays until you know what each one does and which suits you best. Most of the large suppliers will sell small bags of around 1kg (2.2lb) or send samples for you to try. However, designing your own bodies when you have time will be a very useful exercise in understanding your materials.

China clay (kaolin) (Al_2O_3 $2SiO_2$ $2H_2O$) – melting point 1770°C (3218°F)

- China clay (kaolin) is the primary constituent when making a porcelain body, with typically 50% being used.
- The particle size of kaolin is comparatively large, which contributes to its non-plastic nature.
- Kaolin provides both alumina and silica, which are both very refractory materials and account for its high melting point. British kaolins contain mica, a natural flux, so less feldspar is needed.
- Florida kaolin is slightly more plastic than English kaolins, which are whiter and more suitable for translucent bodies. In the USA mixtures of the two are common.

Feldspar – melting point 1200°C (2192°F)
Potash feldspar (K_2O Al_2O_3 $6SiO_2$)
Feldspar provides the main fluxing agent in a porcelain body, facilitating the melting of quartz and clays. Typically, 25% is used in a body.

Potash feldspar or orthoclase (potassium aluminium silicate) is the most commonly used flux in formulating a body. It is a crystalline mineral with a high alumina content which melts slowly into a white viscous glass at stoneware temperatures.

Porcelain bodies commonly use potash feldspar. It is more refractory than soda feldspar.

Soda feldspar (Na_2O Al_2O_3 $6SiO_2$)
Soda feldspar or albite (sodium aluminium silicate) is a more powerful flux than potash, and can give a brighter colour response, which can be an advantage in porcelain glazes. It has a more limited temperature range than potash feldspar, volatilising at 1200°C (2192°F), and can be used to lower the firing range of a body.

A feldspar should be chosen that is low in both iron and titania (the raw material used to produce titanium – TiO_2).

Cornish stone (K_2O Na_2O Al_2O_3 SiO_2) – melting point 1250–1350°C (2282–2462°F)

Cornish stone, is a useful alternative to the above feldspars: a powdered white granite – mainly a quartz, feldspar and mica mix – that can be used as a flux. It has a higher temperature range than the other commonly used feldspars, which will raise the maturing point of the body. Potclays Stone is a synthetic substitute.

Nepheline Syenite (NaK_2O Al_2O_3 $5SiO_2$) – melting point 1100–1200°C (2012–2192°F)

It is also possible to replace some of the feldspar with nepheline syenite in both body and glaze recipes. This is a mineral mixture of feldspar and hornblende. The lower melting point means there may be some loss of strength in the fired body and some hardness in the glaze.

Where feldspar is the principal flux in a glaze recipe (45–50%), an addition of about 5% nepheline syenite will lower the firing temperature by two cones.

Ball clay (Al_2O_3 $2SiO_2$ $2H_2O$) – melting point 1100–1200°C (2012–2192°F)

The percentage of ball clay added to a porcelain body is typically 10%, which combined with china clay brings the total up to an average of 50% of the total mass in any porcelain body.

Many plastic ball clays are available. Being low in iron the English ball clays tend to burn to a very light colour and have been used extensively in the whitewares industry. Because of the fine particle size and high plasticity of ball clay, additions of about 10% make a considerable improvement to porcelain bodies. They also improve the dry strength of wares, making them easier to handle. The fired body is also denser and stronger.

Quartz (SiO_2) – melting point 1710°C (3110°F)

Typically, 25% is used in a porcelain body and must be used together with a flux. It forms the crystalline structure in the fired matrix with mullite from the feldspar and clay. Quartz can be somewhat opaque so it's important to choose carefully when translucency is paramount. It generally increases body expansion and makes glaze fit easier. However, too little quartz in the body can make glazes craze.

Flint (SiO_2) – melting point 1700°C (3100°F)

Flint is ground from certain types of high-silica rock and is often used as a substitute for quartz as a source of silica in bodies and glazes.

Bentonite (Al_2O_3 $5SiO_2$ $7H_2O$)

Bentonite can absorb ten times its weight in water, and can swell up to 18 times its dry

weight. Owing to its structure of stacked platelets with no hydroxyl bonds it is extremely plastic and forms a slippery gel which, when added in very small amounts to a body, can improve the throwing qualities. However, too much will make the clay unpleasantly sticky. It also has an iron content that will affect the colour of the fired porcelain.

Macaloid (CaO MgO Na_2O TiO_2 Al_2O_3 SiO_2 Fe_2O_3 SO_4 LOI)

Macaloid can be used as a substitute for bentonite in porcelain bodies as it contains much less iron oxide. It increases plasticity but also increases shrinkage due to the considerable amount of water it absorbs. Very small quantities should be used, i.e. not more than 1.05%–3% of the total weight of the clay body. It should also be mixed well with warm water before being added to a clay body.

COMMERCIALLY AVAILABLE PORCELAIN BODIES

In the UK the main manufacturers and suppliers of prepared porcelain bodies are based in the traditional pottery-producing area of Stoke-on-Trent. They have an excellent variety to suit most purposes. Most clays are sold in 12.5kg (27.5lb) bags, and the different brands can vary somewhat in water content. Most makers prefer the body to be soft and to control the drying to their preferred consistency.

There are two methods of manufacture with different degrees of purity in the finished product. The first is pan-milling, which controls the water and grog content but may have some contaminants. The other method is slip-housing, which produces a smooth refined body. It is prepared in very large batches in the form of finely sieved slip. This purified slip is passed over electromagnets to remove any iron particles and then pumped into presses for dewatering before being put through a pug mill.

Potclays Ltd have been the leading UK supplier for more than 70 years, exploiting their own clay mine in Staffordshire. They produce five different porcelain bodies in a dedicated plant, as well as a casting slip and a porcelain paper clay using the LB Southern Ice body. Their powdered materials are graded through 150 mesh.

Valentine Clays Ltd use china clays from New Zealand and Cornwall. All their porcelain bodies are made in-house using the slip-house method with shredded and lump materials mixed with water in a blunger, a machine expressly designed for this purpose. They are then sieved and passed over electromagnets to extract any iron pollution, then filter-pressed and finally put through a pug mill.

Valentine's clays are sent out at a medium consistency of between 6.5 and 7.5, as measured by a clay hardness tester. Their porcelain paperclays are made using a dry mixing method using refined powders and fibres.

All their casting slips and pouring slips are made from the various clay bodies mixed with water and deflocculant, using different-sized blungers, to the required pint weight.

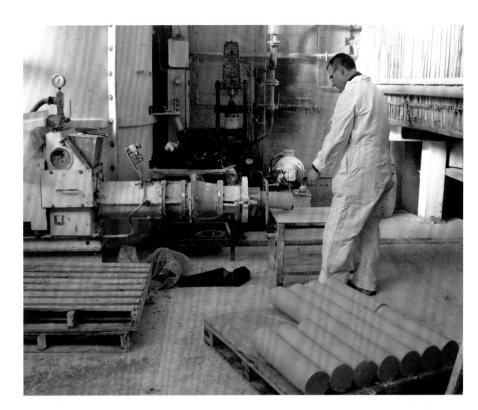

RIGHT: Pug roll being extruded. *Photo: courtesy of Valentine Clays Ltd, Stoke-on-Trent, UK.*

BELOW: Porcelain filter press. *Photo: courtesy of Valentine Clays Ltd, Stoke-on-Trent, UK.*

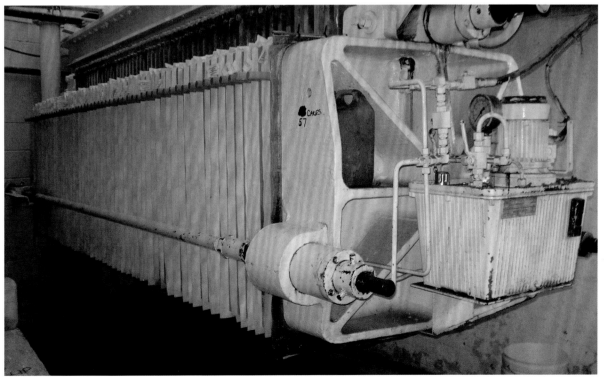

Properties of porcelain bodies in the form of prepared clays from British suppliers and manufacturers						
PROJECT	BODY P = POTCLAYS V =VALENTINE'S	TEXTURE / COLOUR T = TRANSLUCENT USES	FIRING RANGE	HOW PLASTIC?	HOW DOES IT TURN?	HOW PLASTIC IS IT AFTER RECLAIMING?
Small/medium thrown wares	P: Southern Ice	T= Very Very smooth/pure white	1220-1300°C (2228-2372°F)	Good	Poor	Good
	P: Cool Ice	T= Very Very smooth/pure white	1180-1230°C (2156-2246°F)	Good	Poor	Good
	P: DL Porcelain	T= Fair Very smooth/pure white	1220-1290°C (2228-2354°F)	Very good	Very good	Very good
	V: Glacier Porcelain	T= Very Very smooth/very white	1250-1280°C (2282-2336°F)	Very good	Very good	Very good
	V: P2	T= Fair Smooth/white; throwing, modelling and casting	1220-1250°C (2228-2282°F)	Good	Good	Very poor
	V: Royale	T= Good Very smooth/pure white; throwing, modelling	1180-1280°C (2156-2336°F)	Very good	Very good	Very good
	V: Margaret Frith	T= Fair Smooth/white/some specks	1180-1280°C (2156-2336°F)	Very good	Very good	Good
	V. Ming Porcelain	T= Good Smooth/white; throwing and modelling	1220-1280°C (2228-2336°F)	Very good	Very good	Very good
Handbuilding, sculpture, modelling	V: Audrey Blackman	T= Very good Smooth/pure white; throwing and modelling	1180-1280°C (2156-2336°F)	Very good	Very good	Good
	V: Grogged	T= Yes Grogged with molochite/ white	1180-1280°C (2156-2336°F)	N/A	N/A	Fair
	V: Special	T= Fairly good Very smooth/pure white with bentonite	1250-1280°C (2282-2336°F)	Good	Good	Fair
Large-scale thrown and constructed works	V: Industrial	T= No Smooth/off-white/slightly waxy/some iron specks	1180-1220°C (2156-2228°F)	Good	Good	Good
	P: JB Porcelain	T= Yes Smooth/off-white	1220-1290°C (2228-2354°F)	Good	Good	Fair
	P: Harry Fraser Porcelain	T= No Smooth/very white	1220-1290°C (2228-2354°F)	Very good	Very good	Good
Sculpture with paperclay	P: Southern Ice	T = Yes white/textured	1220-1300°C (2228-2372°F)	N/A	N/A	Fair

Artist recipes

Several porcelain bodies have been developed by makers in response to their own needs. Dorothy Feibleman is famous for her colour-inlaid *nerikomi* vessels, Audrey Blackman made rolled porcelain figurines, and David Leach continued the family tradition in making thrown domestic wares. They all worked with Stoke-on-Trent manufacturers to produce commercially viable bodies for porcelain artists.

SLIPS OR ENGOBES

A slip must be as near in composition to the body as possible, being basically thinned mixtures of porcelain that can be poured, sprayed, brushed or slip-trailed onto green wares.

I make my porcelain slips by salvaging turnings from the wheel which are easy to slake down and soak overnight before sieving through a 120 mesh. I then adapt them so that I can spray them onto bisque wares by adding 50:50 by wet weight with a made-up coloured glaze, and then make further additions of powdered glaze stain to adjust colour if necessary before sieving again.

Another recipe to try is 60 parts feldspar, 40 parts china clay plus up to 8% of colouring pigment.

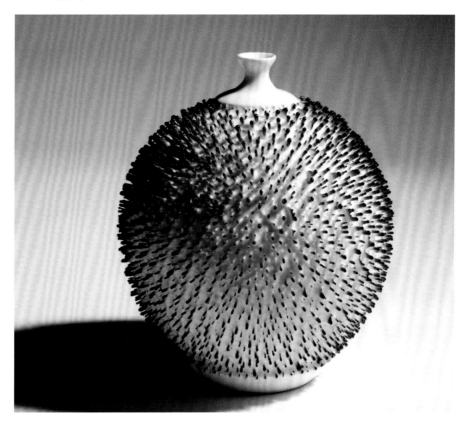

Yun Ju Cheol (Korea), *Cheomjang 111225*, protuding molecule technique, 2011. Each protrusion is constructed with multiple layers of slip. H: 17cm (6¾in) x D: 17cm (6¾in). *Photo: courtesy of Korea Craft and Design Foundation, Seoul.*

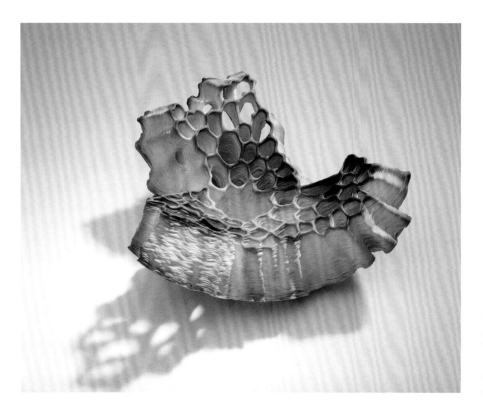

LEFT: Sidsel Hanum (Norway), *Pongwe*, 2010. Constructed with lines of slip in a plaster mould, L: 12.5cm (5in). *Photo: courtesy of Galleri Format, Oslo.*

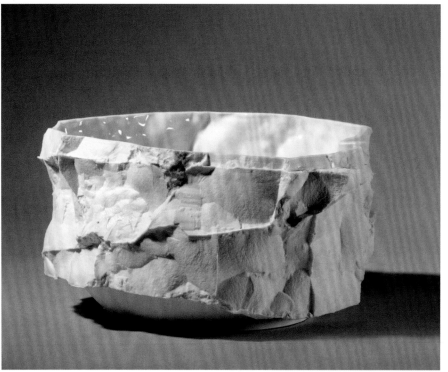

LEFT: Monika Patuszyńska (Poland), *Transforms*, 2010. Slipcast forms made from smashed and reconstructed plaster blocks. H: 26cm (10¼in). *Photo: Czeslaw Chwiszczuk.*

RIGHT: Sueharu Fukami (Japan), *Untitled*, 2012. Slipcast, injection-moulded. Pale blue glaze, granite base, H: 138cm (54½in) x W: 33cm (13in) x D: 28cm (11in). *Photo: courtesy of Yufuku Gallery, Tokyo.*

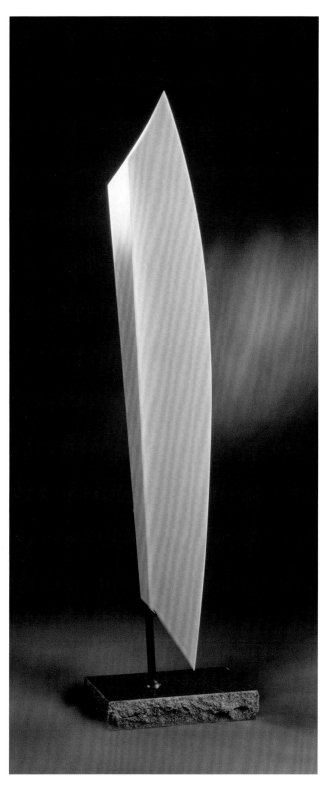

Casting slips for use in plaster moulds

Slipcasting with plaster piece moulds is an industrial process that can be adapted to the small studio.

Some commercially supplied clay bodies are available in powdered form, and also as pre-prepared slipcasting mixtures in either powder or liquid form, with the necessary deflocculants added. Potclays produces a paperclay casting slip using flax fibres in LB Southern Ice clay.

Potclays's slips are prepared to a specific gravity (or litre weight – a measure of the density of the substance) of 1.7–1.8 (34–36oz per pint). They are deflocculated ready for use but can be thinned slightly with a few drops of Sodium Dispex per gallon.

In the studio

Apart from casting plaster to make the moulds, you will need some mixing machinery for producing good-quality slip: either a professional blunger or, if working on a small scale, a strong electric drill fitted with a paint mixer. With large quantities it is essential to blunge, or mix, your slips for at least an hour or, ideally, several hours to achieve a perfectly suspended slip.

If you are making your own slip in the studio, your dry powdered porcelain body, with some further additions of sodium silicate and sodium carbonate, can be made to produce a casting slip. Additions of 0.25–0.5% of deflocculant (usually sodium silicate and soda ash) plus water will be needed. Deflocculated slips have the advantage of needing only about half the water of a simple clay and water mixture; thus the moulds will not become saturated and drying times will be speeded up. Clay and water slips also shrink excessively in the mould and tend to stick. The commercially available product Sodium Dispex is also useful for slip adjustments.

Over-addition of flocculants will cause cracking and sticking of the casts to the mould, while under-additions will cause slips to thicken when left standing.

A recipe from Clayworks Australia for making a slip from LB Southern Ice body is: a 10kg (22lb) block of porcelain, 4g of soda ash, 12ml of sodium silicate,

5–10ml Dispex and 2.2l (4.5 US pints) of water, mixed as follows:

- First dissolve all the Soda Ash in 2 litres of water in a 20-litre bucket, then add the sodium silicate. Mix thoroughly.
- Finely shred in the clay, and mix thoroughly with a strong electric drill fitted with a paint stirrer.
- Add Dispex, small quantities at a time, as required.
- When the slip is well mixed and at a workable viscosity, allow to stand for 24 hours.
- Thoroughly mix again and using 1% solution of sodium silicate in water readjust the viscosity if required.
- The mixture can be passed over a strong magnet if you have one.
- The litre weight can be as low as 1650 grams per litre (58.20 ounces per pint).
- NB: Do not add undiluted sodium silicate to the slip.

For recommended further reading see the Bibliography (p.139).

MARBLED OR AGATE WARES

Blocks of two or more differently coloured clay bodies can be sliced and slammed together and thrown (keeping the initial coning to a minimum), giving a random marbled pattern which becomes sharp when the vessel is turned. The disadvantage of marbling is that the clay cannot be reclaimed unless the slop is adjusted by being stained darker, much as in fabric dying.

The technique is known in Japan as *neriage*.

PAPERCLAY

Porcelain paperclays have been developed in response to a need among artists to produce work on a much larger scale than is normally possible whilst retaining the ideal of a white body.

They are extremely strong and lightweight, making the logistics of handling sculpture much easier. Flax and cellulose fibres are chopped and added to the body with binders. These clays are unusual in that they can be worked on, and joins made, even when dry.

If too much fibre is added the ware will be stronger at green stage but weaker after firing. It is not practical to throw with paperclay, though it could be interesting to use it to extend thrown works. Reclaimed paper clay can lose strength and be rather brittle when fired, as the fibres degrade somewhat, but it can be used as a filler for cracks.

RIGHT: *Preparations for throwing three marbled vessels.*
1. Single-coloured blocks made up with Potclays JB body with additions of 50g (2oz) of colouring oxide per 75g (3oz) of clay.
2. Blocks with alternate layers of plain and coloured clay ready for throwing.
3. Vessels fired to 1250°C (2282°F).
Photos: © VF

RIGHT: Nuala O'Donovan (Ireland), *Radiolaria. Subtracted Grid 3*, 2013. Porcelain paperclay. 1240°C (2264°F). Multiple firings, D: 42cm (16½in) x H: 28cm (11in). *Photo: Janice O'Connell.*

1

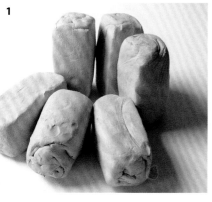

2

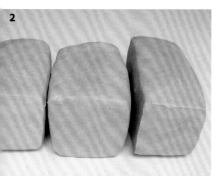

3

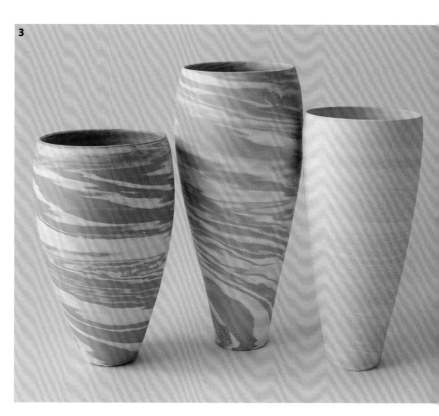

UNDERSTANDING YOUR MATERIALS

Preparing your own porcelain body is a major decision and ultimately has to be a practical one depending on space and outlay in terms of machinery. Though it might suit a small production studio with shared facilities to invest in a pug mill, etc., it most certainly is not worth the effort or expense in the case of someone working on their own in a small space, bearing in mind that a certain amount of clay will remain within the pug mill. The quantities produced might be quite small but the investment in time is considerable.

Processing clay requires space for extra bins and plaster blocks. Dust in the studio should be kept to a minimum. Work areas and equipment should be easy to wash down. Drying porcelain slop on bricks, in bisque-fired bowls, or on the top of the kiln for days encourages a dusty and unhealthy work environment. It is better to air-dry the clay slop in large open bins and firm up a few kilos on your plaster block the day before using.

However, I do recommend that all ceramic artists make some experimental bodies in order to understand their materials. Understanding the relationship of one material to another in terms of plasticity, shrinkage, translucency and whiteness, dry and fired strength, etc. is an important way of gaining experience and hopefully developing one's own design vocabulary.

Other design criteria concerning the finished ware must also be taken into account. The desired temperature range for both body and glazes will have a bearing on the surface quality of the fired ware, while thermal shock resistance is also an important factor when making domestic wares.

It is easy to produce a few kilos at a time to test with different glazes.

Before making up a porcelain body it is useful to observe the melt, the shrinkage (see chart below) and the colour of separate materials. Tiles should be dipped with a slop of each raw material screened through a 120 mesh sieve and fired within the temperature limits planned for subsequent glaze firings.

Raw materials for a porcelain body fired to Cone 9			
CHINA CLAY	BALL CLAY	FELDSPAR	QUARTZ
Powdery/white	Fused/dry/off-white	Melted/transparent	Fused/dry/white

SIMPLE EXPERIMENTS

After deciding whether the body is required for throwing or handbuilding, the next decision should be to determine the temperature range.

The few materials constituting a porcelain body should make formulation simple. However, even small adjustments can make a significant difference.

A good starting point would be 25% kaolin, 25% ball clay, 25% feldspar and 25% quartz or flint. Using this formula it is easy to make up enough clay to throw a 1kg (2.2lb) vessel.

After firing this mixture, ideally to between cones 9 and 11, further trials, making small increments or subtractions of a specific material, can be made to achieve more or less plasticity, whiteness or translucency depending on the ultimate use for which the clay has been designated. Having determined your weights, be sure to keep accurate records.

Your test tiles (see chart above) will give you a clear idea of the properties of the individual materials.

Remembering that more ball clay makes for greater plasticity at the expense of whiteness, the following permutations can be tried:

- Reduce or add feldspar at the expense of ball clay – to determine fired maturity.
- Reduce quartz and replace with kaolin – to adjust glaze fit.
- Reduce ball clay and replace with kaolin – to decrease plasticity if the body becomes too sticky.
- Add bentonite to a maximum of 3% – to increase plasticity.

The limits of the materials required for a true porcelain body are approximately:

- 25% feldspar is the minimum required for a translucent body.
- Less than 10% quartz or flint will make glaze fit very difficult.
- 65% combined kaolin and ball clay is the maximum addition for plasticity.
- Never use more than 5% bentonite and ideally less than 2%.

To lower the firing temperature:

- Increase the feldspar and lower the quartz or flint to three or four parts.
- To lower still further, substitute feldspar for nepheline syenite.

SHRINKAGE

One of the main challenges of working with porcelain is its high shrinkage, which is the main cause of cracking and warping and will also be a crucial factor in glaze fit.

A graphic demonstration of shrinkage can be made by accurately marking lines of 10cm (4in) on tiles rolled from throwable clay. Measure at leatherhard, bone-dry,

Shrinkage test (Potclays David Leach porcelain body)	
STATE OF CLAY	SHRINKAGE
Plastic	10cm (4in)
Leatherhard	9.8cm (3.85in)
White dry	9.5cm (3.75in)
Bisque-fired to 1060°C (1940°C)	9.4cm (3.7in)
Glost-fired to 1250°C (2282°F)	8.7cm (3.4in)

and at bisque and glost stages to determine the various shrinkages, and test several different bodies before adopting one for production (see chart above).

Most porcelain bodies have an approximate linear shrinkage of 14% from the throwable body to the fired state at around 1260°C (2300°F), which is a major factor in handling the material and requires skill if cracking is to be avoided. Stoneware in contrast has on average a 10% linear shrinkage rate.

When designing a body, makers have a choice of materials – particularly feldspars with different melting points – which help determine the final firing-temperature range.

HOW TO PREPARE A PORCELAIN BODY

It goes without saying that with all ceramic practice it is crucial to keep careful and retrievable notes of all your experiments. Have a recipe list in front of you to tick off the materials as you work; it is all too easy to forget which ones you have added, as so many dry powders look the same.

It is important to wear a face mask as there will inevitably be some dust.

- First half-fill a large bin with water and weigh up the china clay. Carefully tip this into the water and close the powder bin. Then tick this ingredient off your list and follow the same routine with each subsequent material.

- When all the ingredients have been added, stir the wet mixture carefully. It should be of a very sloppy consistency with plenty of water; it can now be sieved through a 120-mesh screen into another bin. I use a stiff washing-up brush to work the slop through the mesh. If the mixture is too thick and difficult to work, it can be sluiced through with more water.

- Allow to settle overnight and then adjust it to a usable consistency by pouring off some of the water, before sieving through a 120-mesh screen for the second time.

- Over the course of a day or two keep pouring off the water until the slop can be poured onto a plaster slab. As the water is absorbed, turn the mixture periodically so that crusts do not form. Once you can roll the clay into a mass, it can be air-

dried in towers or loops and left for a few hours. Finally, these can be slammed together and wedged thoroughly, before being wrapped in polythene or stored in an airtight bin.

Most clays benefit from ageing. The normal time for commercial production is about six weeks, beyond which the plasticity changes only very slowly. Potclays Ltd find that the greatest benefit is with powder-blended clays, and that porcelain being sliphoused changes only slightly. For experimental studio purposes it works perfectly well to use a new mix as soon as it is ready.

It is thought an advantage, if not a rule, to store clay for weeks, months or years to allow it to develop plasticity, and indeed this is common practice on an industrial scale, and was certainly traditional practice in China.

Some recipes for porcelain bodies						
COUNTRY	KAOLIN/ CHINA CLAY	BALL CLAY	FELDSPAR	QUARTZ/ FLINT	WHITING	BENTONITE
UK Harry Fraser	Standard porcelain china clay 62		FFF Feldspar 20	13	1.5	Quest white bentonite 4
UK	45	Hymod 17	25	13	-	-
UK	25	25	25	25	-	-
UK	50	-	25	25	-	2
USA Cone 11	Georgia 10 Florida 15	25	25	25	-	-
USA Cone 11	Georgia 10 Florida 25	25	25	10	-	-
USA Cone 11	Georgia 25 Florida 15	10	24	25	1	
France Cone 11	44		30	25	1	-
France Cone 11	40	10	25	25	-	-

Working with porcelain

A vast archive of porcelain art has been handed down to us, providing an almost limitless database and inspiration for those wanting to discover the fascinating variety of ceramic forms and beautiful glazes from the world's collections. Others want to break the mould, and break with the past, to make porcelain perform as never before.

In terms of scale, Felicity Aylieff has worked with the skilled Chinese throwers of Jingdezhen in producing contemporary works on a gigantic scale. Nuala O'Donovan shows us what is possible with paperclay, by making intricate and airy structures. In their respective fields of slipcasting and throwing Monika Patuszyńska and James Makins work in unconventional ways to create new forms and sizzling colours.

Often, a maker's decision to specialise in a particular field is taken early on. But before they can do that, it is important to consider what aspect of design is of most interest, because the porcelain body, the method of construction, the glaze and the firing temperature all follow, and will also determine how the studio is organised. Bear in mind that a workspace where both stoneware and porcelain can be used is difficult to rationalise, as porcelain bodies can so easily become contaminated, and having to provide dedicated areas, as well as duplicating equipment, is complicated and expensive.

LEFT: Yoichiro Kamei (Japan), *Lattice Receptacle 04*, 2004. Created through repetition of slipcast units. H: 35cm (13¾in) x W: 35cm (13¾in) x D: 35cm (13¾in). *Photo: Motoyuki Okuda.*

RIGHT: James Makins (USA), *Untitled*, 1993. 37 x 51 x 51cm (14½ x 20 x 20in). *Photo: Joshua Schreier.*

On starting up, a ceramic artist will almost certainly find practical restrictions. In art college a large kiln and ready access to sophisticated machinery and supplies of expensive materials have all been taken for granted. Finding yourself in a studio space with limited resources can therefore be daunting. However, having initially decided to work in porcelain, the choices open to makers are so numerous and varied that it is no bad thing to narrow down the options even more and become really proficient in one area of design and production. Experimentation within a narrow context can be very liberating.

To reach the stage of being proficient and successful with porcelain takes a great deal of patience and perseverance and a willingness to cope with failure. Opening a kiln full of wasters – work that has taken weeks or months to complete – can be soul-destroying. Even though you learn through your mistakes, happy accidents are rare.

It is vitally important with porcelain more than any other clay to be ruthless in weeding out substandard work before firing. Porcelain is the finest clay of all – associated with quality and refinement – and so the finishing of greenware should be meticulous. It can also be a very unforgiving medium, and a crack will remain a crack. Moreover, repairs made with proprietary fillers are always obvious. Luckily greenwares can be reclaimed, though admittedly, as some bodies are better than others for this purpose, this is a strong factor to consider when designing your own or buying a commercial body.

SOME BASIC STUDIO REQUIREMENTS

I am a strong believer in keeping things simple. It is very tempting to go through a catalogue and want to order numerous shiny things, but many of the most essential tools can be improvised, or made to suit requirements.

Firstly, a plaster block for clay preparation is the number one priority. It can be made with the help of an assistant. Find a cardboard box of suitable size, ideally 51 x 51cm (20 x 20in). Line with a sheet of polythene and prepare and pour a 25kg (55lb) bag of potter's plaster – preferably a general-purpose plaster rather than a very hard casting plaster, (approx. 2.8kg/6.2lb to 1 litre/2.1 US pints of water) to a depth of 7.5cm (3in).

The block will take some weeks to dry out completely, but having cured it will last forever if you are careful never to scrape it with metal tools. I have used mine since 1965 in all my studios, and it is still going strong. I have heard that preparing clay on a plaster block reduces plasticity, but I have never found this to be the case. The absorbent surface makes it very quick and easy to prepare clay straight from the bin to exactly the consistency you want, and this is key to successfully making a thrown form.

STORAGE OF CLAY

Because porcelains can dry out even in the double bags in which they are supplied, I find it easier to cut the clay into slices and cover either with sheets of wet foam rubber, or simply with water, in a large airtight storage bin. If the clay is too soft (which will certainly be the case if you have made up your own body), bring enough out for the following day's work and stand in towers on the bench overnight. By morning it will be easy to wedge and knead on your plaster block to the right consistency. This is much easier than battling with clay which has become too hard.

If you feel the clay is a little on the hard side it can be saved by poking holes through the mass with the end of a wooden spoon and filling them with water. Leave for a short time then knead after damping down the plaster block with a wet sponge.

However, it is better to think ahead about the consistency and organise enough clay for the next day's work.

TOOLS AND ACCESSORIES FOR THROWING AND TURNING

To buy:

1. A small selection of boxwood modelling tools
2. A 30cm (12in) boxwood ruler
3. Three or four metal ribs
4. A few turning tools
5. Two pairs of callipers
6. A supply of fine baby sponges
7. A supply of 15cm (6in) tiles to lift pots onto (tiles are more manoeuvrable than planks).

Add to your tool collection as you go along and see what you need.

To make:

1. A chopstick with a piece of sponge bound to the end for mopping the bottom of thrown pots
2. A long needle stuck in a champagne cork for trimming
3. Strip tools of different sizes made from strips of steel banding
4. A metre of fabric interlining material cut into 15cm (6in) squares to cover tiles (which act as a barrier between the pot and tile), for use when lifting wet pots off the wheel. These squares can be washed and reused many times. NEVER use newspaper, which will disintegrate and make your turnings unreclaimable
5. A length of heavy-grade fishing line tied to toggles at each end for cutting pots from the wheel.

CLASSICAL THROWING

Becoming proficient as a thrower, achieving a confident style, takes many hours and even years of practice, but once that style has been established it is as distinctive to the individual as handwriting.

When making wheel-thrown forms it is absolutely essential to spend time preparing clay to exactly the consistency required for the style of work. The general rule is that early faults can only get worse. When wedging and kneading porcelain on the plaster block, it is important to be thorough and to eliminate air pockets which will distort the form when throwing. If the clay is too wet it will fold over on itself and gather air pockets, while the thrown form will be weak and will only hold up with very thick walls and a vestigial shape. Too dry and the clay will be unevenly mixed, hard to knead and to centre, and will also have trapped air pockets. So aim for a piece of clay which kneads easily but has some resistance in the hand. Porcelain tends to dry out quicker than stoneware, so it is important not to prepare too many clay balls in advance of throwing. I do have a superstitious feeling that freshly prepared clay has a memory of my hand in it and is therefore more plastic. (For information on wedging, see Richard Phethean's book *Throwing*.)

When throwing and turning porcelain, the practices are the same as for other clays. However, some porcelain bodies are more responsive than others and it is usually a case of coaxing the clay rather than being too robust on the wheel. After centring the clay and making the first pull upwards it will be immediately apparent if there is an air bubble, in which case it is better to start again. Even if the piece survives it can lead to trouble when turning or in the final firing.

It is very common for porcelain vessels to develop an S-shaped crack in the base as they dry. Vessels with a very wide diameter are difficult to cut off the wheel head and also risk cracking. I find that compressing the base by running the end of a boxwood ruler from the centre out to the wall after the first pull up will eliminate this problem (Boxwood is especially durable) . Allowing the piece to dry slowly and evenly will also help.

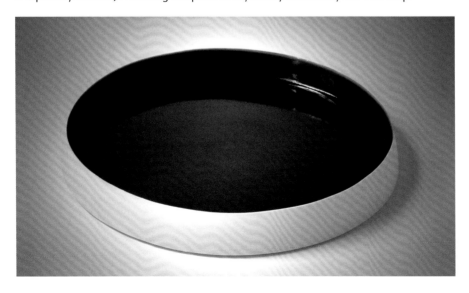

Daniel Smith (UK), blue flat dish, 2012. D: 33cm (13in) x H: 6cm (2¼in). *Photo: courtesy of the artist.*

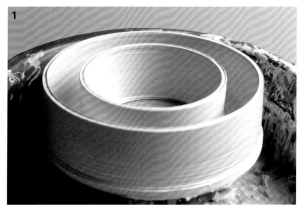
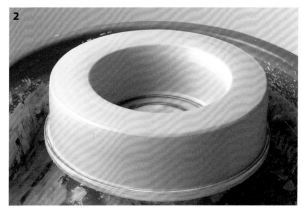
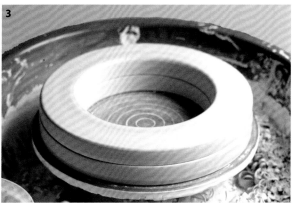

Vivienne Foley. *How to construct a necklace box.*

1. Throw a double-walled form. D: 30.5cm (12in).

2. Draw the two rims together and square off.

3. The constructed box at leatherhard. Galleries have been turned in the top half. In the bottom half the inside walls have been turned to accommodate the galleries in the top half.

4. The interiors (fired with top and bottom in place to 1260°C/2300°F).

Photos. © VF

To cut off, water the wheel head and, using the fishing line, gently slide the piece onto a tile lined with fabric. Allow it to dry to the stage when it is safe to lift and then reverse the form onto the bench. Rims will dry out too fast, so protect them with a coil of thin polythene. Success with porcelain very much depends on controlling the drying. The weather has a marked effect on this – you will notice differences in your work rhythms on dry or rainy days and between winter and summer. Always visit your work regularly and if you need to slow down the drying process, sponge the bases and even cover with a damp fabric square, then wrap carefully with polythene if you need to delay the next stage.

Clay has a 'memory'. As it dries and fires it will shrink back on the throwing spiral. Therefore, any handles or spouts will twist off centre unless they are deliberately offset slightly when being attached.

Many throwers choose to use wheel batts in order to throw multiple shapes in one session, or a difficult wide-based form, or like Bill Boyd a large mass (7kg/15.5lb) of centred clay that needs to be hardened somewhat before it can be thrown. But I find that it is too risky to move a complex, thin-walled form: the slightest movement can shift the form off centre and make it impossible to turn accurately later. It is better to be patient and wait a few hours until the piece has stiffened sufficiently to be cut off the wheel.

Bill Boyd (Canada), 2013. Thrown on a wheel batt, crystalline glaze, reduction-fired. 'Dark Star' glaze with 24-carat gold accents, D: 51cm (20in). *Photo: courtesy of the artist.*

FORMS

I aim for walls which rise properly from the base and have well-defined forms. Pots that appear to be sitting on their bottoms look squat and heavy and counteract the upward flow of the piece. There should be a fluency of line and a determined shape, not an accidental one dictated more by the state of the clay than the maker's mind; and the lip should be a definite finale. Weak shapes will never be successful even with a dramatic glaze.

PRODUCTION THROWING

Repetition throwing, as practised by Daniel Smith, is necessary for making production runs such as tableware. Daniel buys one tonne of clay at a time. He throws from 40 to 80 vessels per day and finds it important to weigh each ball of clay to ensure accurate measurements.

Most production throwers say they get into the rhythm of throwing, but with small editions I find that pots need to be checked on the wheel with a ruler and callipers to be consistent.

Daniel Smith (UK), nest of five bowls, 2012. D: 26cm (10¼in) x H: 8cm (3¼in). *Photo: courtesy of the artist.*

Kim Duck Ho (Korea), *Red Dot series*, 2012. Inlaid, reduction-fired to 1280°C (2336°F). D: 16cm (6¼in) x H: 11.5cm (4½in). *Photo: courtesy of Gallery LVS, Seoul.*

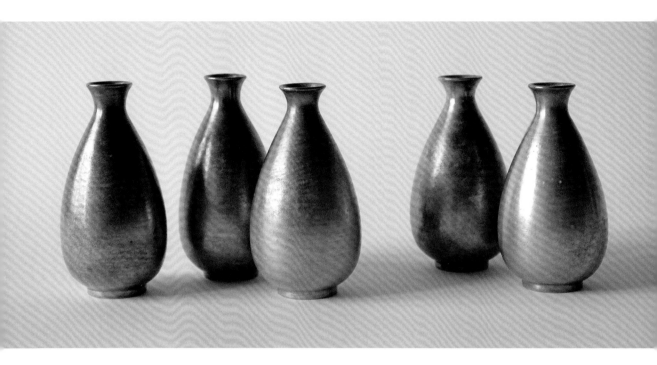

THROWING OFF THE HUMP

Throwing 'off the hump' has been practised for millennia in China and saves time by doing away with having to centre each new ball of clay. First, a very large mass of clay is centred on the wheel head, then a small section at the top is opened for each new piece. The pots become repetitive and the size instinctual.

Edmund De Waal used this technique when making his monumental work *A Thousand Hours*, comprising 1000 small pots expressing a meditative feeling of calmness and the passing of time.

TURNING

The comparative lack of plasticity and strength in porcelain bodies compared to other clays requires the thrown walls to be somewhat thicker. The final refinement at the leatherhard stage takes place with turning, when typically two thirds of the weight is shaved off, or even more if complete translucency is the goal.

The traditional method of turning accurately thrown forms is on a clay 'chuck', a thick clay collar made in various widths and heights to suit the types of forms being made. For this purpose it is best to use a plastic body, such as Potclays JB, thrown very precisely and left overnight to stiffen then cut off the wheel in the usual way. This can be centred and turned minimally top and bottom, then cut with grooves to aid re-centring.

Takahashi Dohachi (Japan) (1910–82), sake flasks, thrown off the hump. Courtesy of Simon Pilling, East Asian Art and Interiors. *Photo: © V F.*

Edmund de Waal (UK), *A Thousand Hours*, installation, 2012. Created from 1000 vessels thrown off the hump. *Photo: Michael Harvey.*

RIGHT: Chucks with grooves to aid centring. Chucks should be kept leatherhard. *Photo: © VF.*

FAR RIGHT: Accurate turning can only be achieved when the chuck and form are securely centred. *Photo: © VF.*

Vivienne Foley constructing *Wishbone*.

1. Joining and turning five thrown and turned forms on the wheel.

2. The final composite form with five sections, fired to 1200°C (2192°F). Unglazed and polished, maximum length: 45.7cm (18in).

Photos: © VF.

Vivienne Foley constructing *Corkscrew*.

1. Final turning of six thrown forms on a chuck.

2. Joined composite form, fired to 1200°C (2192°F). Unglazed and polished, length 45.7cm (18in). Private collection: Moscow.

Photos: © VF.

In use the chuck is re-centred and fixed to the dampened wheel head with coils of non-sticky clay. When the turning job is finished, hold it under the tap briefly and stuff the inside with polythene, then double-wrap again for storage in a cool place. Treated this way, chucks can last literally for years.

Using a chuck is a safe way of turning the insides of bowls, should a completely smooth surface be needed. Towers of chucks can be quickly assembled for tall or unconventional pieces. Most forms, even complex ones, can be centred and anchored to the chuck, turning the foot ring first and then reversing the vessel to complete the task from the rim downwards. When turning the foot of a form with a small

Vivienne Foley, *Jackdaw Sticks*, installation, 2009.

1. Thrown tube H: 40.5cm (16in). Turned in situ.

2. Thrown, turned and constructed. Eight separate composite forms, fired to 1200°C. Polished porcelain, maximum length: 43cm (17in).

Photos: © VF.

opening it is sometimes difficult to judge the thickness of the base and it is easy to break through the bottom. If you remove the piece from the chuck and hold it to your ear, gently tap the base and you can hear how much more thickness you need to turn away.

JOINING COMPOSITE FORMS

Thrown forms with multiple sections can be turned and joined on a chuck if accurate measurements are taken at every stage.

Throwing

1. When throwing the first section, finish the rim with a flat profile. Measure the inside and outside diameters of the rim, and save the measurements on two pairs of callipers.
2. Throw the next section with an open base to the same width.

Turning

1. When turning the first section, complete the foot first, leaving the rim untouched.
2. Turn the inside of the open base of the second section, checking the inside diameter. The width of the wall should match the rim of the first section exactly.
3. With the first section fixed to the chuck, score needle marks evenly across the rim. The second section will have been turned and the base similarly scored.

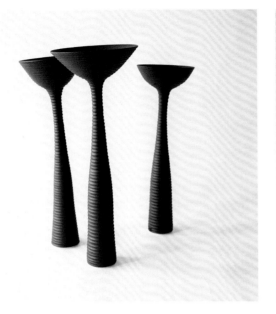

4. Damp both rims with water (not slip, as this can crack) and carefully join the sections, gently at first in case any tiny adjustments are needed. Check the centring. Bear down firmly. Top and bottom sections should be perfectly matched. A groove can be cut at the outside join and a thin coil of clay can be pressed in all around, though this is not always necessary.

5. Smooth over your join by turning the completed form, once it has been allowed to firm up. Don't be impatient as it is easily pushed off centre again if the clay is too soft.

JOINING ASYMMETRICAL FORMS

Separate thrown and turned forms can be joined asymmetrically at the leatherhard stage (bearing in mind the overall balance and weight), which allows you to deviate from conventional forms into more sculptural shapes.

JIGGER AND JOLLYING

Industrialised workshops with big production runs can employ jigger and jollying machinery to mechanise stamped-out forms.

ABOVE LEFT: Vivienne Foley, *Tall Black Flowers*, 2006. Black slip glaze, maximum height: 53cm (20¾in). *Photo: © VF.*

ABOVE RIGHT: Vivienne Foley, *Forked Vase*, 2009. Ivory crackle glaze, H: 27cm (10¾in). *Photo: © VF.*

BELOW: Vivienne Foley, two vases, 2012. Black magnesia glaze, and ivory crackle glaze. Max. H: 30cm (11¾in). *Photo: ©VF.*

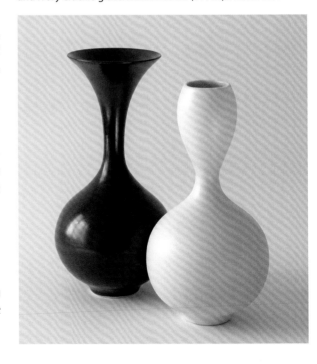

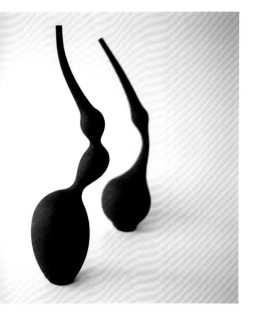

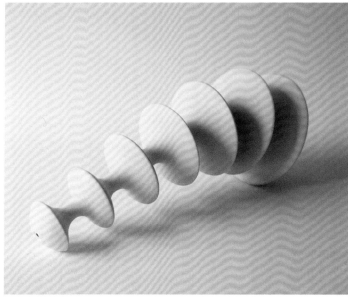

ABOVE LEFT: Vivienne Foley, *Double Balance, Single Balance,* 2000. Black basalt porcelain, max. H: 51cm (20in). *Photo: © VF.*

RIGHT: Vivienne Foley, *Spine,* 2009. Thrown and constructed, polished porcelain. L: 43cm (17in). *Photo:©VF.*

MECHANICAL TURNING AIDS

There is now a mechanical device that fixes to the wheel head to aid turning, which can be useful for simple forms or production work.

UNCONVENTIONAL THROWN FORMS

Unusual sculptural or vessel forms can be wheel-thrown in several stages and need not be hollow, or turned, or thrown and altered at different stages of drying (see also Chapter 5, p.95).

FINISHING

The more a piece is finished while wet or leatherhard the less work there will be at a later stage, so go over the raw work to remove any crumbs of clay left by the turning. Rims should be sponged lightly with one quick movement, bearing in mind that glaze pulls away from sharp edges.

SLIPCASTING

Slipcasting is usually associated with industry or commercial studios making domestic wares, but it is very possible for a porcelain artist to use the same techniques in a creative way, and on a small scale, or where multiple components are needed for figurative work or sculpture.

Slipcasting can be useful for forms that are difficult to throw or for producing paper-thin translucent vessels or elements which can be pierced or carved. In this regard, Cordula Kafka and Jeremy Cole produce contemporary lighting designs which exploit the fundamental quality of porcelain, translucency, to the full.

Peter Biddulph has brought mould-making into the 21st century by creating 3D digital forms using open-source software on a Linux platform; these are subsequently rendered as physical objects using rapid prototyping technology. The plaster casts taken from these generated objects are then used in a slipcast process to produce sculptures using LB 'Southern Ice' slip.

Monika Patuszyńska, by smashing and reassembling her plaster moulds, creates an 'inside out' structure with her porcelain casts which is at once dynamic and provoking (see also Chapter 3, p.40).

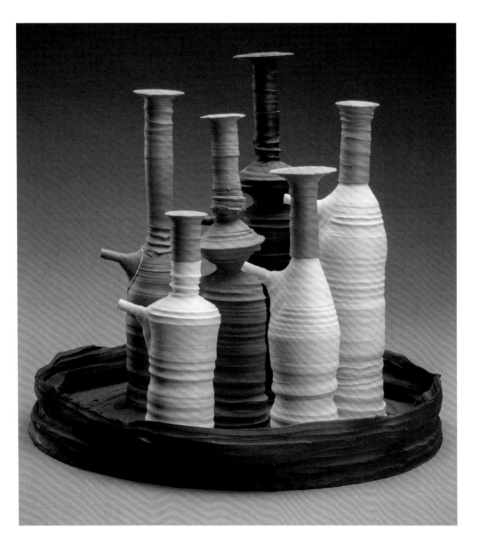

LEFT: James Makins (USA), Hermitage decanter set, c.1998. 35.5 x 51 x 51cm (14 x 20 x 20in). *Photo: Ken Yanoviak.*

RIGHT: Yasuko Sakurai (Japan), *Vertical Flower*, 2013. Slipcast porcelain. H: 53.2cm (21in) x W: 33cm (13in) x D: 35.5cm (14in). *Photo: courtesy of Yufuku Gallery, Tokyo.*

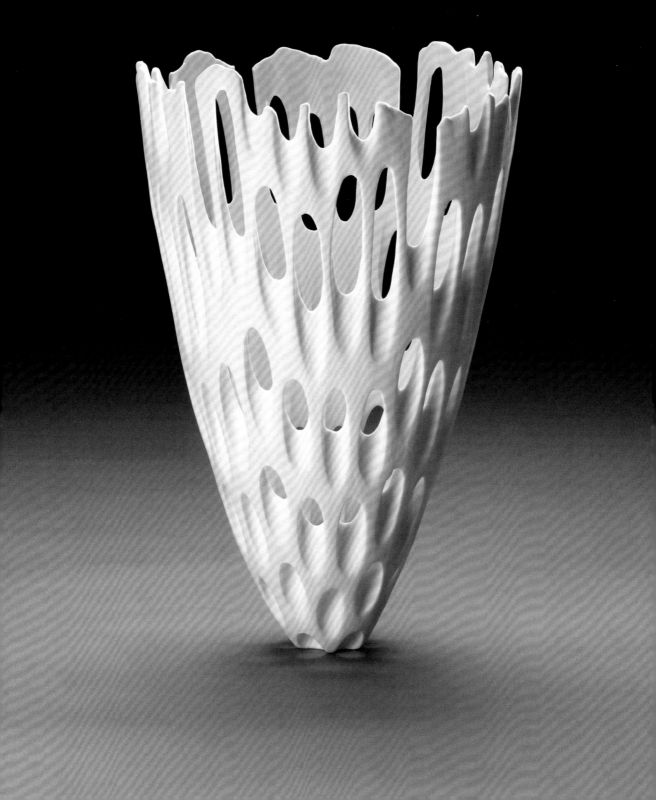

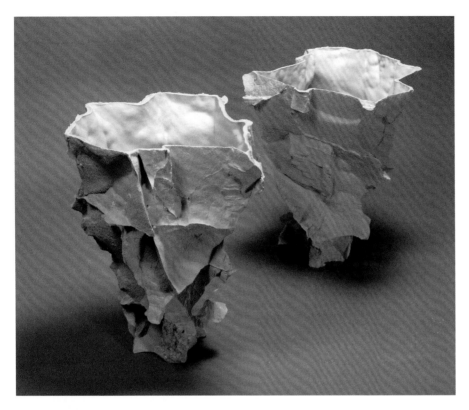

Monika Patuszyńska (Poland), *Para Forms*, 2010. Hollow, slipcast from a smashed and reassembled block of plaster, H: 27cm (10¾in). Gas-fired to 1260°C (2300°F). *Photo: courtesy of the artist.*

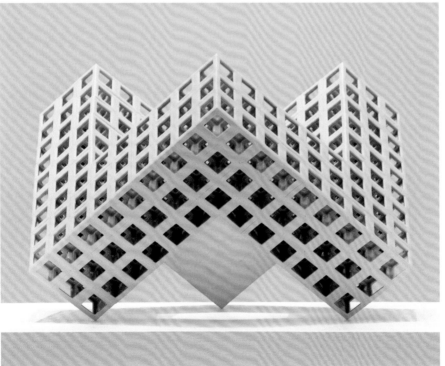

Yoichiro Kamei (Japan), *Lattice Receptacle 06*, 2006. Created from repetition of slipcast units. H: 35cm (13¾in) x W: 35cm (13¾in) x D: 35cm (13¾in). *Photo: Seiji Toyonaga.*

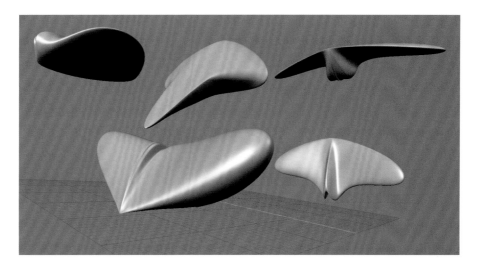

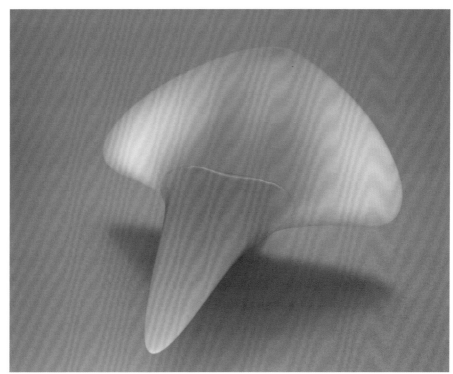

TOP: Peter Biddulph (Australia), *Biomimesis*, 2008. 3D Computer image.

RIGHT: Peter Biddulph (Australia), *Generated Object in Porcelain 1: Biomimesis*, 2008, H: 20cm (8in) x W: 17cm (6¾in) x D: 5cm (2in). *Photo: courtesy of the artist.*

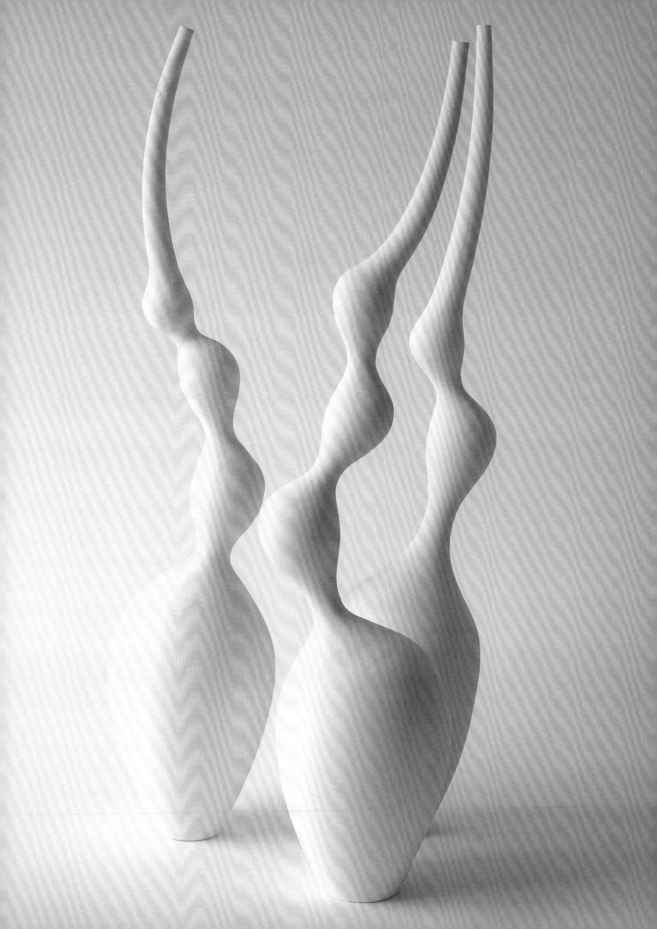

5

Forming and finishing porcelain

Perhaps the greatest glory of porcelain is the range of options the medium offers for forming and finishing. Because ceramic artists are starting out with a pure white material it somehow frees the mind for creative expression, much as a blank white canvas or sheet of paper would do for a painter.

Now, as always, the great themes in art are love and war, nature, death, politics and religion, and today's ceramic artists are no more immune to these tides than those working in other media. Chinese-Australian artist Ah Xian, whose scope goes beyond ceramics, has found porcelain to be a material which in itself has cultural and emotional resonance. The contradictory qualities of fragility and durability, and the search for continuity and personal identity in an increasingly complex international world can find expression in, and add layers of meaning to, sculptural form.

Ceramic sculpture can also be disturbing or provocative either in its form or surface treatment or in the message conveyed, and in the case of some artists, the work is driven by a burning personal issue. Historically however, the white surface of a plate or vessel is the perfect place to make a statement, and its durability will outlast a poster or newspaper. Examples can be found from Soviet Russia to Nazi Germany to Maoist China, and indeed in gentler vein the long-established traditions of souvenir china in the West.

LEFT: Vivienne Foley, *White Balance group*. Max: 61cm (24in) x 61cm (24in). Thrown, turned and constructed (14 parts). Polished porcelain. *Photo: © VF.*

RIGHT: Ah Xian (China / Australia), *China China Bust no.34*, made in Jingdezhen, China, 1999. Overglaze iron red with applied Bo Gu (many antique objects). H: 39cm (15¼in) x W: 40cm (15¾in) x D: 21cm (8¼in). *Collection and courtesy of the artist.*

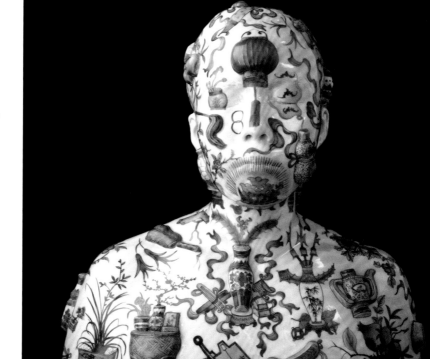

Thrown vessels especially can be quietly contemplative, with unadorned forms which somehow evoke a spiritual response, connect with our humanity or are simply elegant. Let us look at some of the many possibilities for forming and finishing which are available to today's porcelain artists.

HAND-FORMING METHODS

Porcelain is traditionally an unsuitable material for handbuilding. Methods which are standard with other clays present challenges with porcelain. By its very nature the work will be heavy and need a great deal of refining to come close to the porcelain ideal. However, there are many contemporary exceptions – artists such as Dorothy Feibleman and Paula Bastiaansen – who have refined their work with great artistry. But handbuilt slab or coiled forms can be problematical, with uneven shrinkage and seams prone to splitting.

On the other hand, those without throwing skills will always be attracted to the purity of the material and will want to make pinch pots with fine fluted or translucent edges. Sandra Byers chooses to work on a very small scale. Her sculptures are so carefully considered and beautifully executed they could easily be scaled up without losing their integrity. Just as they are they become intimate and treasured objects.

BELOW: Sandra Byers (USA), 2009. *Top left: Bend*, 5 x 8.25 x 3.2cm (2 x 3¼ x 1¼in); *top right: Eight*, 2011, 5 x 7.3 x 5cm (2 x 2 ⁷/₈ x 2in); *bottom left: Open*, 2011, 5.4 x 10.8 x 4.8cm (2¹/₈ x 4¼ x 1⁷/₈in); *bottom right: Cocoon*, 2010, 8.25 x 10.8 x 4.4cm (3¼ x 4¼ x 1¾in). Handbuilt and carved. *Photos: Courtesy of the artist.*

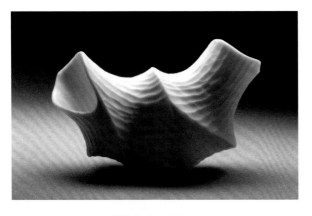 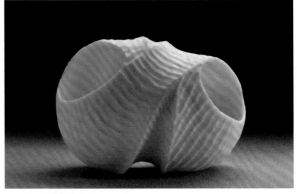

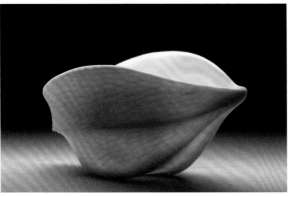 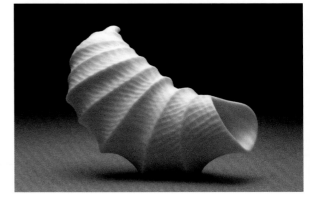

Katharine West (Ireland), *Light Things*. Porcelain elements in a glass and steel box. 30 x 30 x 20cm (12 x 12 x 8in). *Photo: courtesy of the artist.*

SCULPTURAL AND FIGURATIVE WORK

The construction of sculptural and figurative works often combines several different construction methods such as throwing, coiling and slab-building, building forms with pellets of clay, or a combination of the use of plaster piece moulds with additional hand-modelling. Ah Xian's porcelain busts were initially fabricated from life casts of his family and friends.

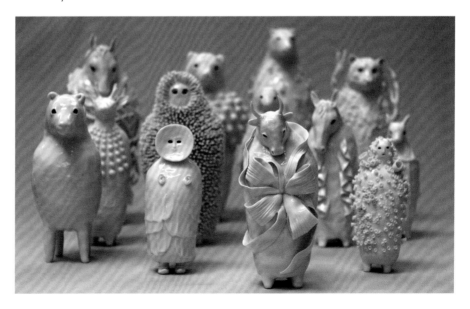

Sophie Woodrow, *Crowd*, 2011. Porcelain clay with transparent glaze, H: 15–35cm (6–13¾in), made by pinching, coiling and inscribing.

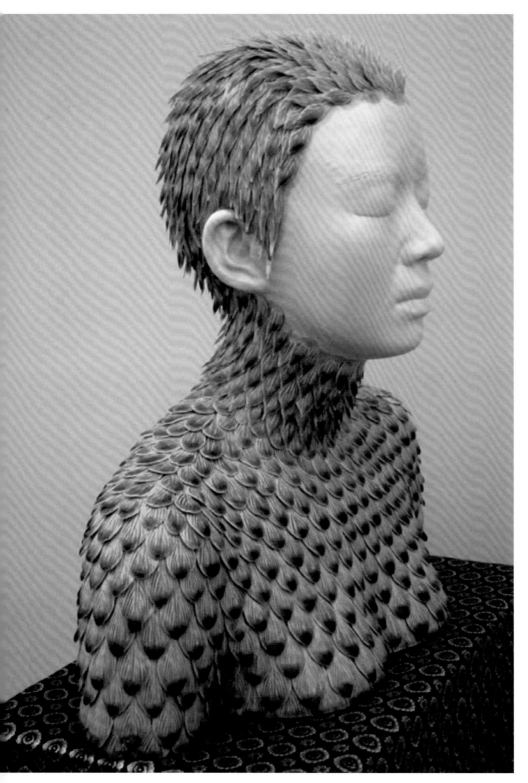

LEFT: Ah Xian (China/Australia), *China China Bust no. 67*, 2002. Made in Jingdezhen, China. Body cast with applied porcelain 'kingfisher feathers'. H: 41cm (16¼in) x W: 40cm (15¾in) x D: 22.5cm (8¾in). *Collection and courtesy of artist.*

RIGHT: Michelle Erickson (USA), *J'aime Et J'espère – I Love and I Hope*, 2003. Thrown and handbuilt porcelain and black earthenware, porcelain slip-trailed decorations with enamel and gold lustre. H: 35.5cm (14in). Collection of Long Beach Museum of Art, CA. *Photo: Gavin Ashworth, NY.*

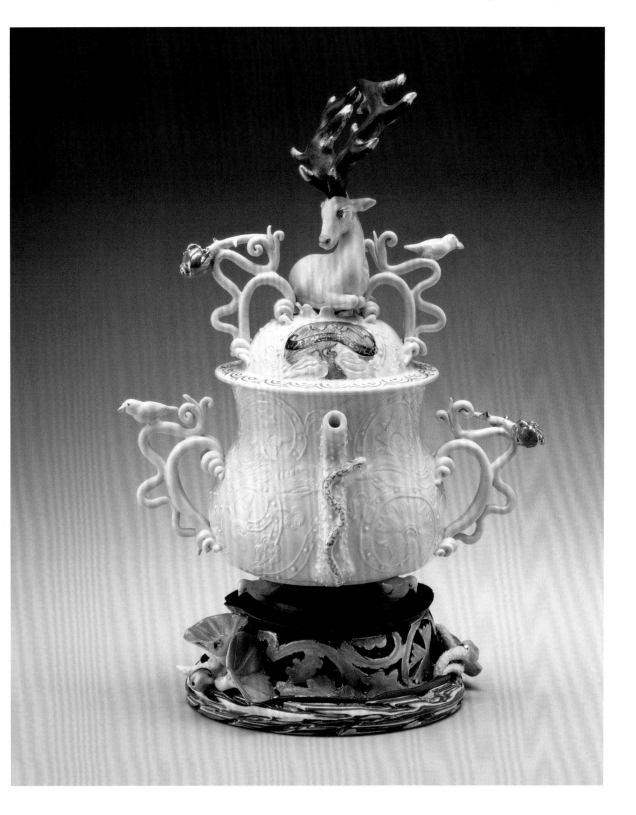

PAPERCLAY

Paperclays offer greater freedom for sculptors when constructing complicated forms; for instance, making joins is easier than with ordinary porcelain and armatures may not need to be removed prior to firing. Paperclay can still be quite translucent where thin and so retain some of the qualities we expect of porcelain (see Chapter 3).

At one time, before paperclay was available, I mixed an electrical porcelain body 50:50 with T material, a grogged clay body, to make extensions on large thrown vessels.

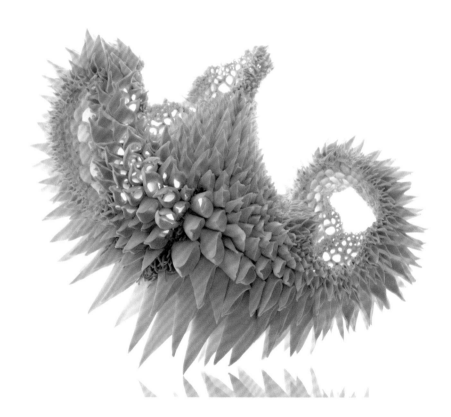

SPRIGGING, PRESS-MOULDING, EXTRUDING

Sprigging has a long ceramic history in China and Japan and became popular in the 18th century when these wares were produced by many of the English and European factories.

Separate clay pieces are made to embellish the leatherhard form. Additions such as leaves or petals or classical motifs are pressed in a plaster or bisque mould, trimmed and joined to the form with slip. These wares tend to be quite heavy.

Extruding can involve machinery or can be as simple as pressing pellets of clay through a sieve.

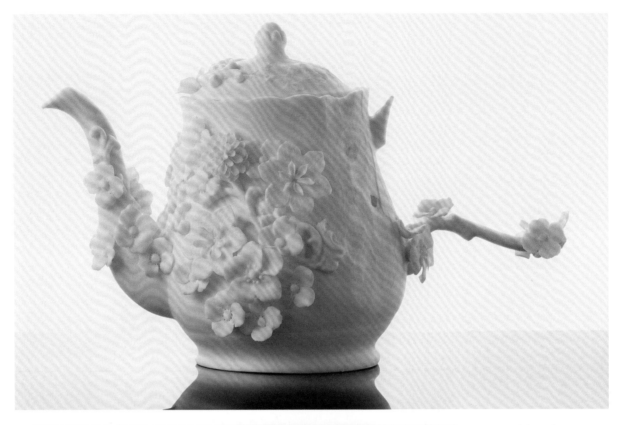

ABOVE: Makiko Nakamura (Japan/UK), *Teapot*, 2011. Slipcast, press-moulded, sprigged and handbuilt, H: 19.5cm (7¾in) x W: 29cm (11½in) x D: 16cm (6½in). *Photo: Ko Kawaguchi.*

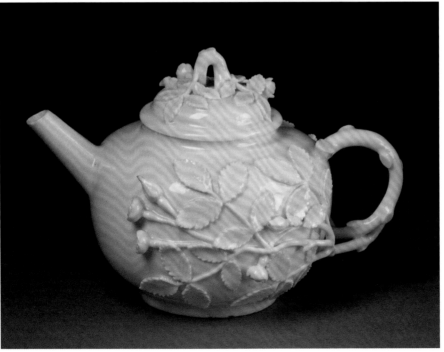

LEFT: Böttger teapot, Meissen, *c.*1715–20. Applied roses and leaves. One of the earliest examples of European hard-paste porcelain. H: 11.8cm (4¾in). *Photo: © Victoria & Albert Museum, London.*

The method is still an attractive device for contemporary makers. Makiko Nakamura is the latest ceramic artist to draw on tradition in a slightly subversive way.

ALTERING THROWN FORMS

The soft and plastic qualities of clay can be exploited by altering and deforming, and by emphasising the throwing rings.

Wet or damp forms can be stretched, slashed or indented before or after being cut off the wheel head. As these forms cannot be turned their weight will be a consideration.

After turning, with or without making a foot rim (a finely turned foot will warp during firing if the form is pre-distorted), and at the leatherhard stage, cylindrical forms can be softened slightly by wrapping with damp silk for a few minutes, and can also be squared. Open forms such as bowls can be gently squeezed into elliptical shapes giving a flowing profile to a rim, a technique beloved of Lucie Rie.

Leatherhard thrown forms can also be cut, facetted, carved or manipulated, as shown by Pam Dodds, Akihiro Maeta, Jennifer McCurdy and myself.

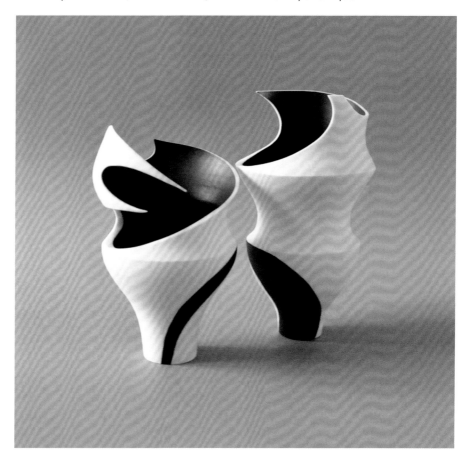

RIGHT: Pam Dodds (UK), *left: While the Tocsin Sounds* (from a poem by Mervyn Peake), 2008. Both porcelain with black slip, 1260°C (2300°F). H: 16cm (6¼in); *right: At the End of the Day* (from poem by Cardinal Newman). H: 17cm (6¾in). *Photo: courtesy of the artist.*

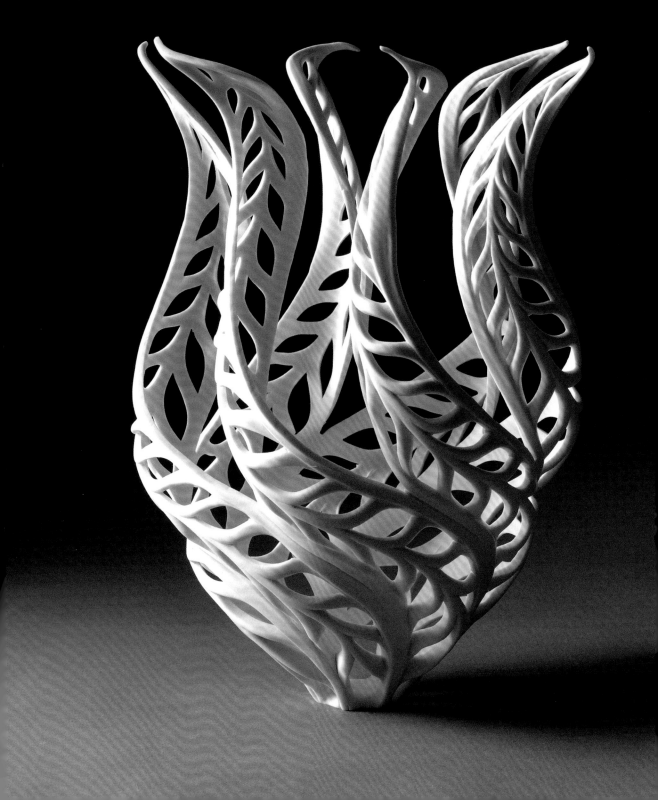

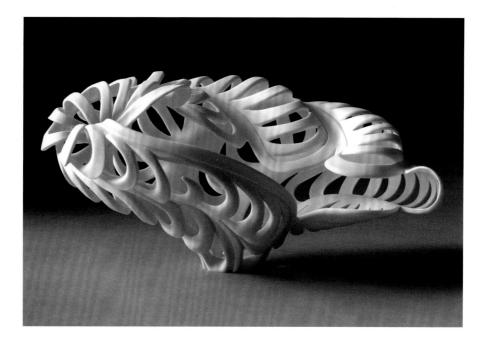

LEFT: Jennifer McCurdy (USA), *Magritte's Butterfly Vessel*, 2012. Thrown and altered porcelain, H: 11cm (4¼in) x W: 9cm (3½in) x D: 9cm (3½in). *Photo: Gary Mirando.*

RIGHT: Jennifer McCurdy (USA), *Rolly Wind Vessel*, 2013. Thrown and altered porcelain, H: 7cm (2¾in) x W: 11cm (4¼in) x D: 8cm (3¼in). *Photo: Gary Mirando.*

INCISING, INLAY AND SGRAFFITO

Incised marks can be made on leatherhard clay. They do not have to be deep to be beautifully accentuated by a thin clear or coloured glaze which pools into the indentations.

The traditional Korean technique of inlaying greenware with coloured slip is known as *mishima*. Excess colour must be removed from the surface, but strong stains such as cobalt can mar the body material, so meticulous finishing is essential.

On thrown pots concentric rings can very easily be cut by incising leatherhard vessels secured on a chuck fixed to the wheel head. These can be filled immediately with coloured inlay and turned, or sanded down when dry, or glazed at bisque to reveal fine lines when fired.

Simple or even very complex designs can be achieved by sgraffito techniques which can made freehand. Patterns can be made by scribing or combing through a layer of slip at leatherhard stage or, after bisque-firing, through a glaze layer.

Lucie Rie employed both inlay and sgraffito techniques on her iconic pots, both at the green and raw glazed stages. She scribed fine horizontal or vertical lines with a needle on her leatherhard thrown pots, and inlaid with coloured slips, or as described above made very precise incised and inlaid lines with the pot carefully centred on the wheel.

Porcelain for inlay techniques can be made from the body material coloured with primary oxides or up to 10% of commercial stains. An addition of 5% whiting can reduce shrinkage and help the inlay to adhere to the groove. If after firing it is proud of the surface it can be polished down with a diamond pad.

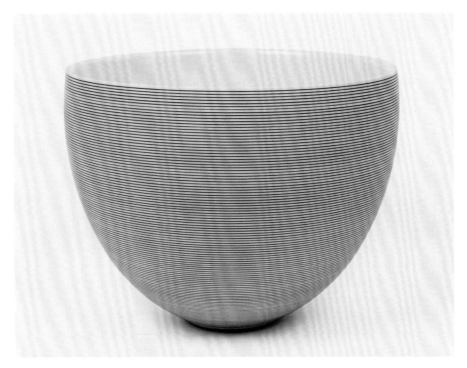

Park Jung Hong (Korea), *Blue Bowl*, 2013. Polished porcelain with blue inlay, D: 31cm (12¼in) x H: 26cm (10¼in). *Photo: courtesy of Gallery LVS Seoul.*

Vivienne Foley, *Bowl*. Sgraffito and colour inlay, Dia: 25.5cm (10in). Private collection. *Photo: © VF.*

RIGHT: Lucie Rie (1902–95) (UK), *Bowl, c.1975. Left:* outside, inlaid lines; *right:* inside, sgraffito through bronze slip. Private collection. *Photos: © VF.*

NERIKOMI

Glass beads created with laminated colours appear in Roman times, but the technique was later refined by the Venetians and came to be known as *millefiori*.

The same technique has been used with ceramics in Japan for hundreds of years, where it is called *nerikomi*.

Dorothy Feibleman has perfected her complex and beautiful *nerikomi* patterns in porcelain. She layers different coloured sheets of porcelain into rods, which when sliced reveal the internal pattern. The slices are then assembled into a mould with extraordinary sensitivity of design and skill.

Nerikomi works are usually left unglazed to show the colours at their purest.

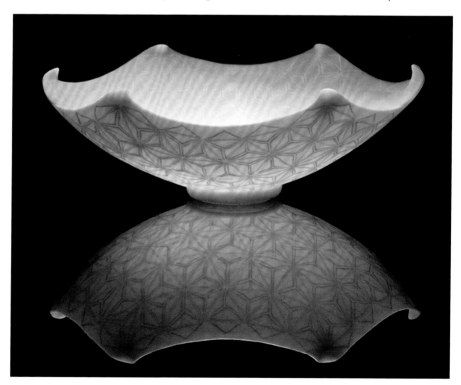

Dorothy Feibleman (USA), *Geometric Star,* wavy edge series, series 2005–10. Nerikomi, D:16 x 7.5cm (6.5 x 3in). *Photo: Abel Lakatos with Dorothy Feibleman.*

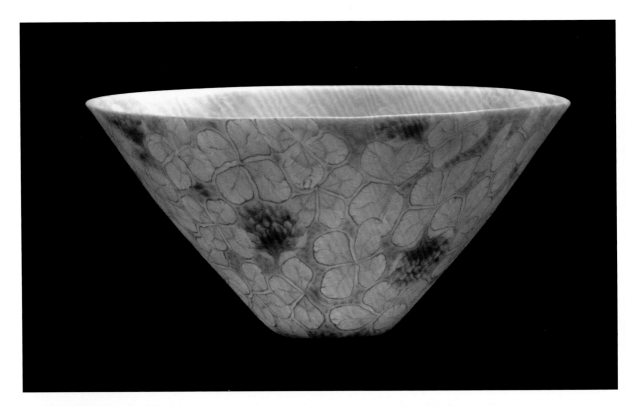

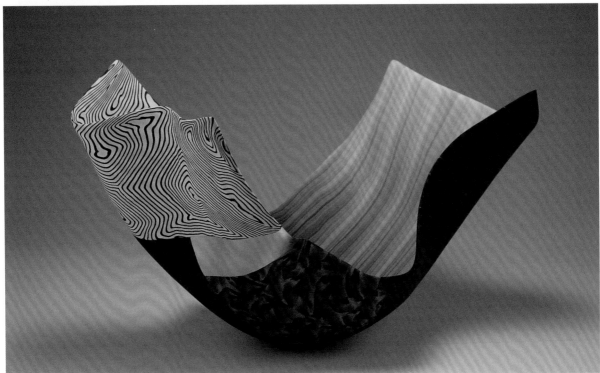

LEFT: Dorothy Feibleman (USA), *Clover Tea Bowl*, series 2005–06. *Nerikomi*, D: 15cm (6in) x H: 7.5cm (3in). *Photo: Yamasaki with Dorothy Feibleman.*

BELOW LEFT: Thomas Hoadley (USA), *Untitled*, 2010. *Nerikomi.* Coloured porcelain, handbuilt, unglazed. H: (21.5cm) 8½in x L: 35.5cm (14in) x W: 20.5cm (8in). *Photo: courtesy of the artist.*

NERIAGE, AGATE OR MARBLING

These techniques can be achieved on the wheel and are described in Chapter 3.

PIERCING

Piercing necessarily requires very thin walls. Patterns can be cut through ultrathin slipcast wares, or thrown and turned wares such as Jennifer Mc Curdy's, at leatherhard stage, or holes can simply be bored with an electric drill at bisque stage.

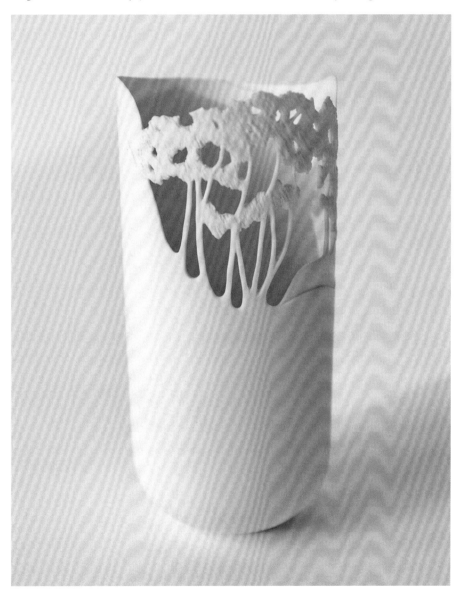

RIGHT: Irene Simms (UK), untitled, c.1978. Slipcast and pierced, H: 10cm (4in). *Private collection. Photo: © VF.*

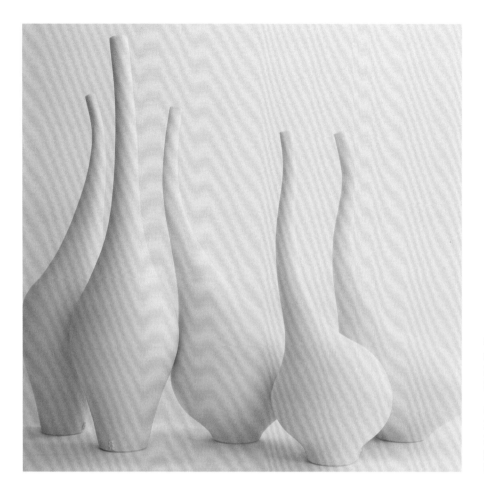

LEFT: Vivienne Foley, *Funnel-necked Group*, 1996. Polished porcelain, Max. H: 42cm (16½in). *Photo: © VF.*

RIGHT: Vivienne Foley, *Tall White Flowers Group*, 2012. Unglazed, polished porcelain, max. H: 57cm (22½in). *Photo: © VF.*

UNGLAZED FINISHES

Porcelain is perfectly suited to being left unglazed. A pure white body with a very fine particle size can be polished to a silky smooth and tactile finish with various grades of diamond abrasives. Bisqueware should be wetted down locally and polished with wet diamond abrasives, to be repeated with wet polishing after glost. Here there is an obvious advantage when working with coloured porcelain bodies.

WALL PIECES AND INSTALLATIONS

Wall pieces used in either domestic or architectural settings can vary in scale from picture size to something of monumental proportions. Traditionally, porcelain tiles have been used in architectural settings on walls or floors with either a repeat design or to span a wall with a mural. Both hand-painting and screenprinting techniques are common.

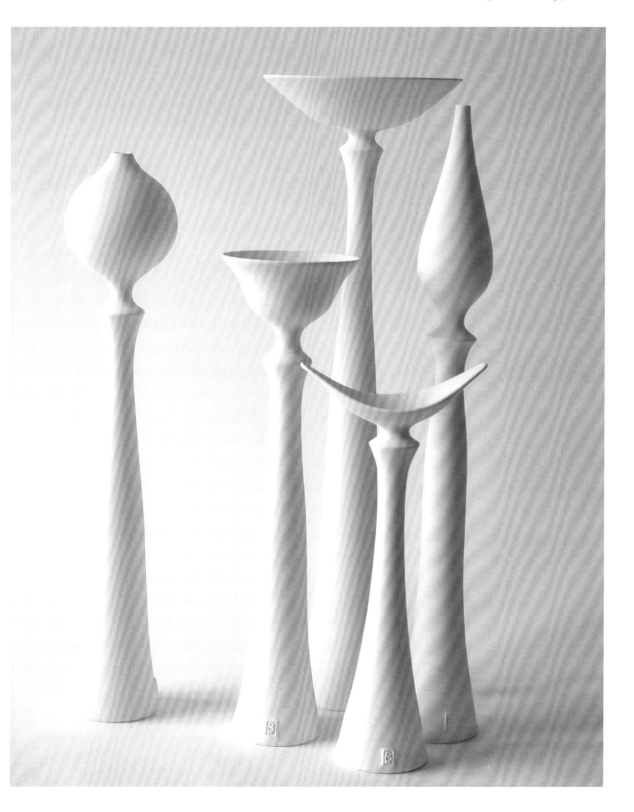

Wall pieces can be created by the large-scale repetition of individual components. Jeanne Opgenhaffen makes rhythmic works of art comprised of hundreds of separate rolled or pressed clay sections mounted on a Perspex backing.

Wall pieces can be quietly contemplative. I developed a way to type my poetry directly onto clay sheets with an electric typewriter. These were then assembled unglazed into wall pieces, the words like fragments of a forgotten manuscript, only legible close up. I also laid these sheets of poetry, the text highlighted with manganese, into shallow bowls and let them slump and fuse into the glaze, a technique which could be used for wall tiles.

Some wall pieces and installations are works of art that go beyond the studio into an environment which will engage the viewer on an intellectual level. Edmund de Waal has exhibited major gallery works composed of over a thousand small, individually thrown components.

At the other end of the scale Felicity Aylieff's monumental vessels are an unrivalled celebration of the potter's art, to be viewed in large public spaces.

RIGHT: Vivienne Foley, *Viewless Wings* wall piece, 2005. Typed directly onto porcelain, fragments unglazed. H: 79cm (31in) x W: 62cm (25in). Photo: © VF.

FAR RIGHT: Jeanne Opgenhaffen (Belgium), *With Simple Words* (detail), 2008. Transfer-printed porcelain. *Photo: courtesy of the artist.*

BELOW: Jennifer McCurdy (USA), *Seascape.* Photo: Casey McCurdy.

BELOW RIGHT: Jeanne Opgenhaffen (Belgium), *Dancing Shadow* wall piece, 2010. Rolled and hand-pressed elements, 2.4 x 1.53m (94½ x 60¼in). *Photo: courtesy of the artist.*

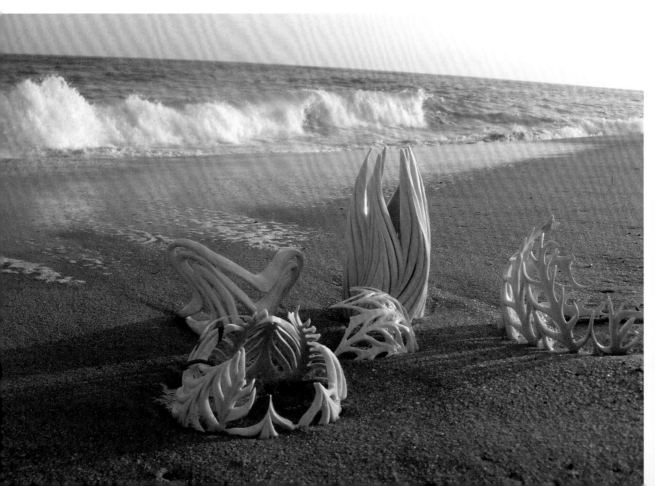

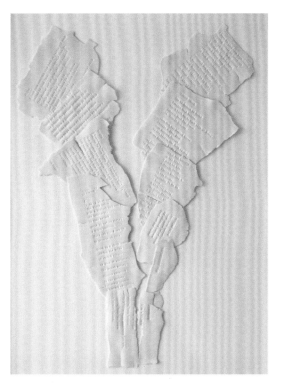

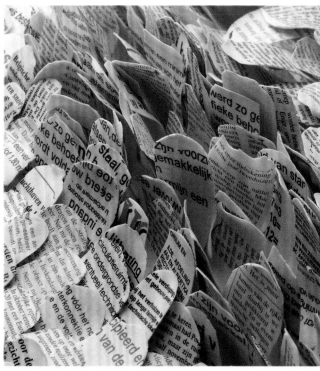

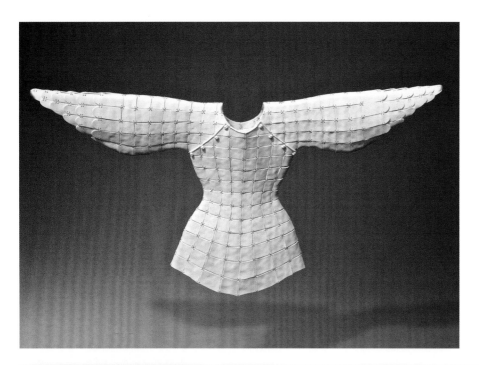

LEFT: Fiona Wong (China/ Hong Kong), *White Venus*, 2012. Installation: sculpture with porcelain plaques, H: 54cm (21¼in) x W: 110cm (43¼in) x D: 5cm (2in). *Photo: courtesy of Themes & Variations gallery, London.*

BELOW: Valéria Nascimento (Brazil/UK), Installation comprising 3500 pieces, Bucherer, Munich, 2013. *Photo: courtesy of the artist.*

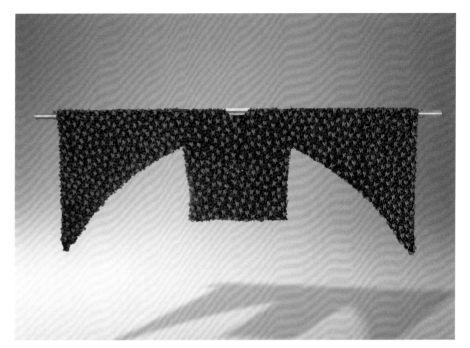

RIGHT: Caroline Cheng (China/ Hong Kong), 2012. top: *Prosperity 2012* and below: *Prosperity 2012* (detail). Porcelain butterflies sewn on to burlap. Installation. W: 190cm (75in) x L: 190cm (75in). *Photo: courtesy of Themes & Variations gallery, London.*

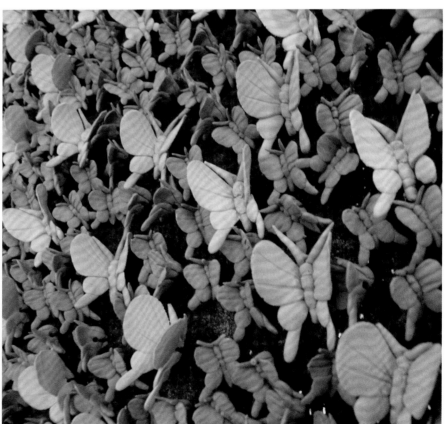

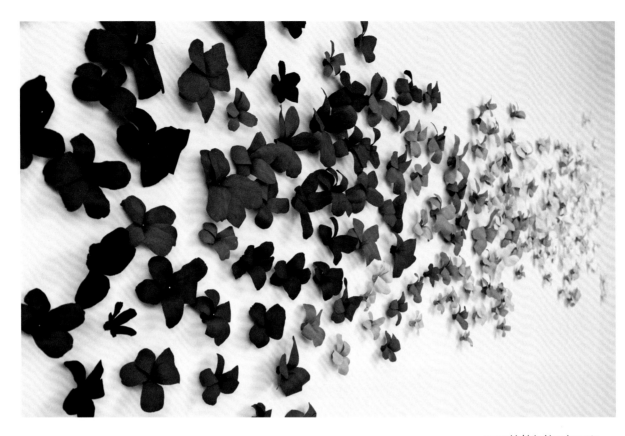

RESIST TECHNIQUES

Complex patterns can be achieved by applying layers of shellac and sponging off, giving gradations of thickness and translucency. Wax or latex resist can be combined with printing techniques. They can also be used at raw or bisque stages to layer colours or define areas for further decoration (see Chapter 6).

SLIPS OR ENGOBES

Graphic effects can be made by manipulating raw clays and glaze with slip-trailing (see also p.39 for slips and engobe information). The imaginative methods used by Yun Ju Cheol (Korea) and Sidsel Hanum (Norway) show what is possible.

SLIPCAST WARE

Slipcasting into plaster moulds is an industrial production technique that can be adapted for small runs in the studio for domestic wares or sculpture (see also Chapter 3).

ABOVE: Valéria Nascimento (Brazil/UK), *Hibiscus Installation*, 2011. H: 120cm (47¼in) x L: 500cm (197in). *Photo: Christopher Pillitz.*

RIGHT: Felicity Aylieff (UK), Installation at Bo Yang Lake, China, 2006. Thrown and constructed, H: 224cm (88½in) x D: 57cm (22½in). *Photo: Felicity Aylieff.*

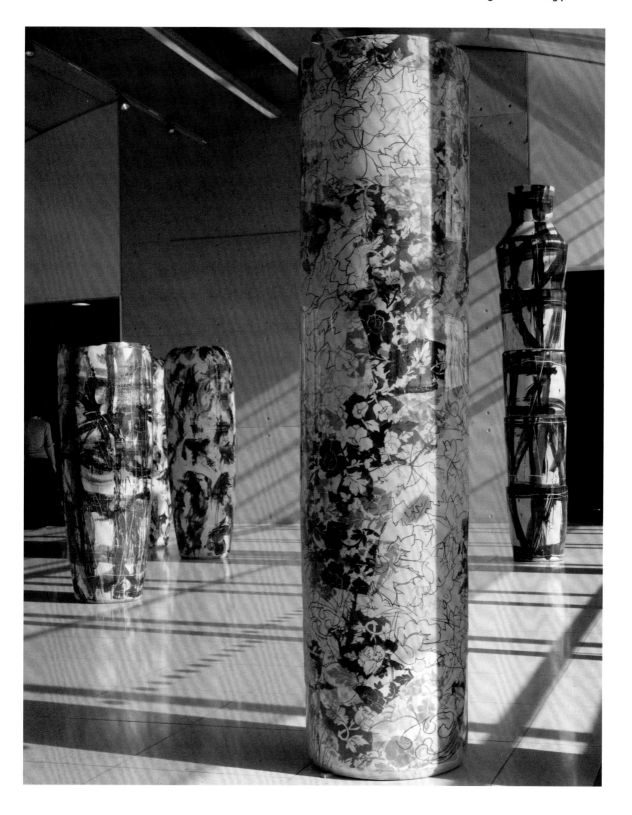

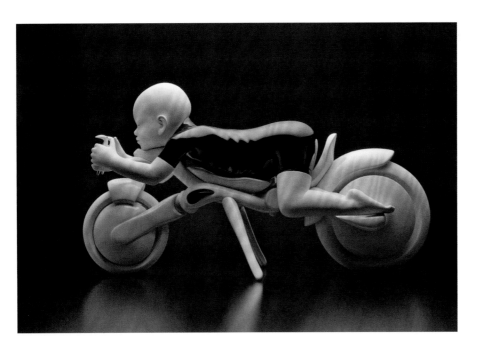

LEFT: Shigeki Hayashi (Japan), *00-1*, 2013. Constructed from slipcast components, glazed and fired to 1230°C (2246°F). H: 42cm (16½in) x W: 80cm (31½in) x D: 40cm (15¾in). *Photo: courtesy of Yufuku Gallery, Tokyo.*

RIGHT: Cordula Kafka (Germany), *Thincut*, 2000. Slipcast, fired to 1400°C (2552°F). 100 x 22 x 22cm (39¼ x 8¾ x 8¾in). *Photo: Reiner Lautwein.*

LIGHTING

The fineness and translucency of porcelain lends itself to being illuminated from within the form, the light given being a soft warm glow. Multiple forms are usually slipcast, enabling a commercial approach, as in the work of Cordula Kafka and Jeremy Cole. However, Peter Biddulph has made a series of thrown sculptural forms utilising LED lighting, and Valéria Nascimento's latest lighting installation in a Paris emporium is made of 3,500 separate hand-pressed petals.

BELOW LEFT: Peter Biddulph (Australia), *Vol_Luminous*, 2005. Ten of 17 wheel-thrown sculptures, with LED fibre-optic cables. Satin-matt glazes, fired to 1280°C (2336°F) in reduction and 1200°C (2192°F) in oxidation. Max. H: 108cm (42½in) x W: 27cm (10¾in). *Photo: courtesy of the artist.*

RIGHT: Cordula Kafka (Germany), *XY*, 2008. Slipcast, fired to 1400°C (2552°F). (X) 30 x 36cm (11¾ x 14¼in); (Y) 35 x 28cm (13¾ x 11in). *Photo: Reiner Lautwein.*

FAR RIGHT: Peter Biddulph (Australia), *Vol_Luminous*, 2005. Wheel-thrown sculpture with LED fibre-optic cables. *Terrebellum* (individual form) Max: H: 75cm (29½in) x W: 45cm (17¾in). *Photo: courtesy of the artist.*

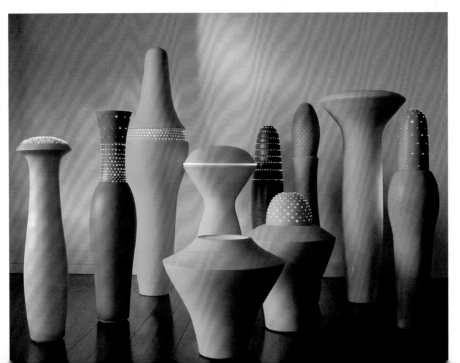

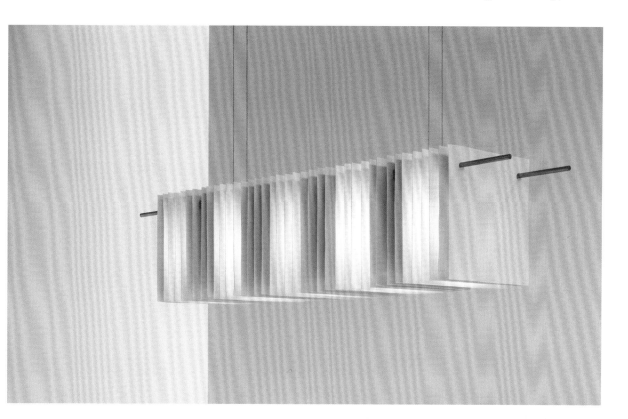

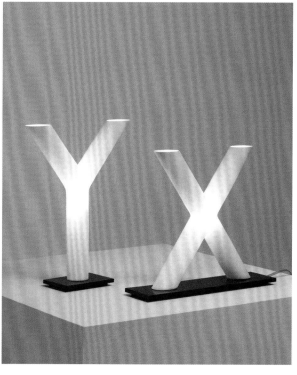

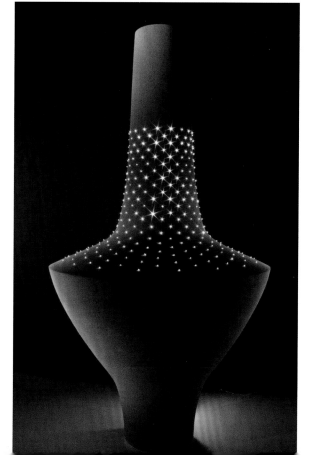

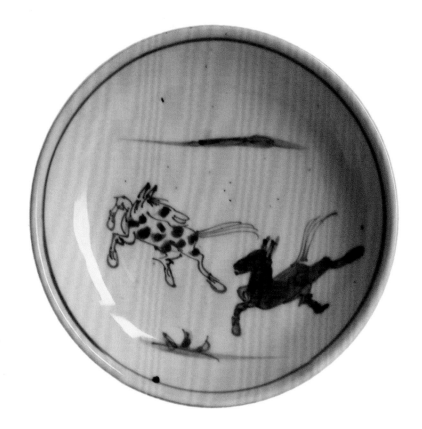

Unrestrained Horses, Chinese, Tianqi, 1621–27. Cobalt underglaze painting, D: 15cm (6in), H: 2.5cm (1in). *Private Collection. Photo: © VF.*

GRAPHIC DESIGNS ON GREEN AND BISQUE WARES

Underglaze painting

Underglaze painting brings to mind the designs executed in cobalt blue which characterise the Ming and Qing periods of Chinese ceramics. Complex scenes were painted with extreme skill on greenwares. They often provided base patterns which were later filled in with on-glaze enamels and re-fired to approximately 800°C (1472°F). The technique developed in the 15th century was known as *doucai* or 'abutted colours'. The technique known as *wucai*, combining underglaze blue in random areas rather than as outlines, and further painted with enamels in five colours, was popular in the 16th and 17th centuries.

Underglaze pigments can also be used in a painterly way on top of raw-glazed bisqueware. Application is easier if the base glaze is still slightly damp.

In-glaze painting

Colour can be introduced selectively by painting or spraying in between glaze layers, which can add depth and subtlety to surfaces.

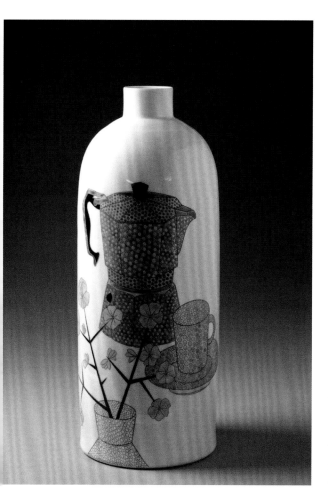

Felicity Aylieff (UK), *Still Life with Coffee Pot*, 2013. Fencai coloured enamels, H: 56cm (22in) x W: 20cm (8in) x D: 20cm (8in). *Photo: Felicity Aylieff.*

Overglaze painting

As we have just seen, underglaze painting can provide a framework design for enamels. The surface for painting is ideally a smooth, shiny glaze without pinholes or craze lines. The pigment must be ground very finely and be mixed with a medium – either fat, oil or gum Arabic-based – and can be painted with fine brushes.

Ceramic enamels can now be found in the whole spectrum of colours, which are useful for predictable results, or they can be intermixed. They have to be fired in a third firing to a low temperature and will provide a permanent finish between 730 and 800°C (1346–1472°F).

Before transfer printing was developed in the mid-18th century, overglaze painting was the ubiquitous method for introducing decorative painting of scenes and motifs to porcelain. It still provides enormous scope for self-expression and fluent painting styles.

Mary White specialised in overglaze calligraphy skilfully adapted to the curved surfaces of her porcelain bowls. Felicity Aylieffe, who works in collaboration with traditional Chinese ceramic factories in Jingdezhen, has made both underglaze and overglaze techniques her own, with a contemporary feel and on a gigantic scale.

Printing

Screenprinted transfers or decals

Porcelain with printed decoration has been with us for over 250 years and is mainly a factory-based process, but it can also be practical for studio-based artists who make small production runs or even one-off pieces. Screenprinted ceramic transfers can give enormous scope. The written word, as poetry, text or propaganda, as well as graphic and photographic images, can be sharply reproduced on vessels and flat surfaces such as tiles, as well as on complex sculptural forms.

Ceramic pigments are mixed with a solvent or water-based medium and are then screenprinted onto gum-coated paper before being slid into position on the porcelain surface and fired to overglaze temperatures of around 800°C (1472°F).

The graphic effects possible with screenprinting are numerous. Printed stencils can be cut and used as collage, giving multi-layered effects. Wax-resist techniques can also be used on the screen. The pigments used can be transferred to green and bisque wares as well as to overglaze, giving a wide range of possibilities.

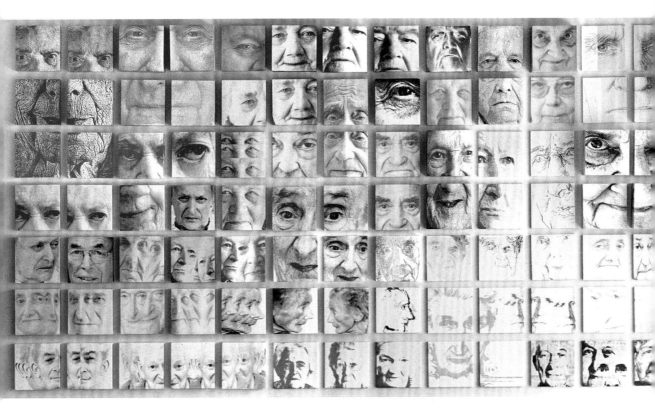

'Photographic' screenprinting with light-sensitive emulsions is another technique to explore, as is digital technology.

For recommended further reading, see Kevin Petrie's *Ceramic Transfer Printing*, listed in the bibliography.

Jeanne Opgenhaffen (Belgium), *Ardooie Daylight*, 2002. Installation, H: 1.70m (67in) x L: 3.20m (126in). Individual tiles 25sq. cm (3.87sq. in). *Photo: courtesy of the artist.*

Sponge printing

Sponge printing is a low-tech transfer method traditionally used on earthenwares, but there is no reason why it cannot be used in a more sophisticated way on porcelain. Sponges are cut to a design, and on-glaze colour or ceramic printing inks can be picked up and stamped onto the newly glazed surface.

Lustres

Metallic lustres are available in brilliant iridescent colours as well as gold and bronze, etc. They are supplied as organo-precious or non-precious compounds in liquid form and can be painted or sprayed. They can also be found in pen form for fine work, and as precious metal inks which can be screenprinted.

As with enamels, glazed surfaces must be grease- and dust-free before application. In Geoff Swindell's well-known work, the surface tension of lustres was broken with the fine point of a brush holding pure turpentine, giving whorls of radiating colour (see also Chapter 6, p.114).

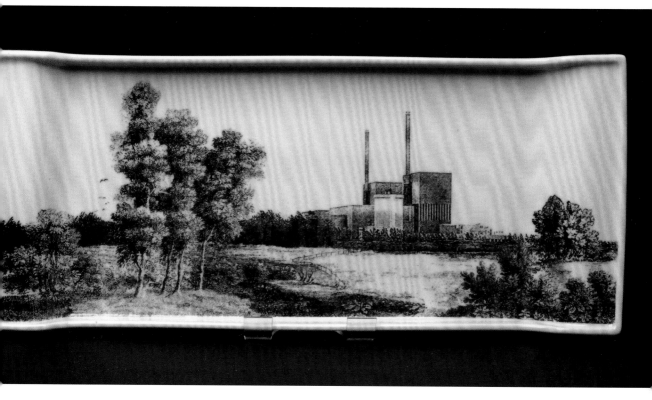

Paul Scott (UK), *Cumbrian Blue(s), Barsbäcke 2*, 2007. In-glaze decal collage with gold lustre on Rörstrand platter designed by Pia Törnell. L: 48cm (19in) x W: 20cm (8in) x D: 4cm (1½in). *Photo: Paul Scott.*

UNCONVENTIONAL TECHNIQUES

As we have seen, nearly all the methods for finishing porcelain have a long ceramic history, but in recent times ceramic artists have gone beyond the boundaries of tradition and have broken the rules to great effect.

Our expectations of porcelain being fine, white and translucent have been turned upside down by the development of vividly coloured clay bodies and unconventional throwing by James Makins. He makes overlapping time structures corresponding to varying wheel speeds and the weight and pace of finger pressure in order to draw three-dimensional lines in space.

Inspired by Wedgwood's 18th-century basalt-stained stonewares, I produced a dense blackware from a porcelain body heavily grogged with black stain. I later adapted this body to make a slip that was much less polluting in the studio.

Paula Bastiaansen works from detailed drawings, laying strips of thinly rolled porcelain onto the pattern, building up a picture and controlling the moisture content before reconstructing in a pre-fired stoneware mould for firing.

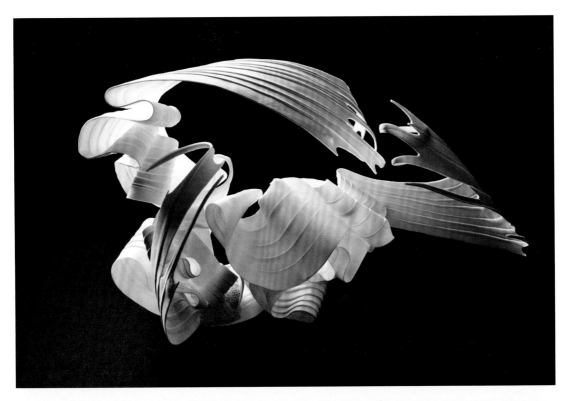

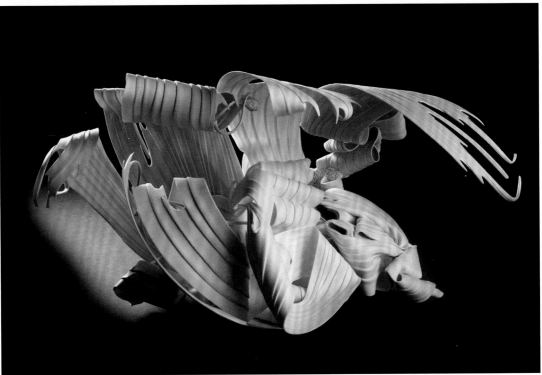

TOP LEFT: Paula Bastiaansen (Holland), untitled. Thinly rolled and constructed. H: 30cm (11¾in). *Photo: Marja van Hassel.*

BELOW LEFT: Paula Bastiaansen (Holland), untitled. Thinly rolled and constructed. H: 47cm (18½in). *Photo: Marja van Hassel.*

RIGHT: Nuala O'Donovan (Ireland), *Grid, Hidden Blue*, 2011. Multiple firings, H: 33cm (13in) x W: 33cm (13in) x D: 23cm (9in). *Photo: Janice Connell.*

BELOW: Valéria Nascimento (Brazil/UK), *Spirals Sequence*, 2011. Wall piece, H: 50cm (19¾in) x L: 200cm (78¾in). *Photo: courtesy of the artist.*

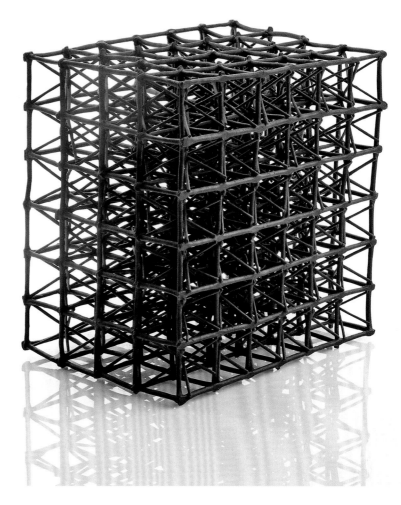

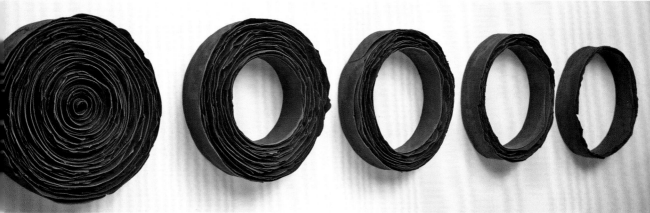

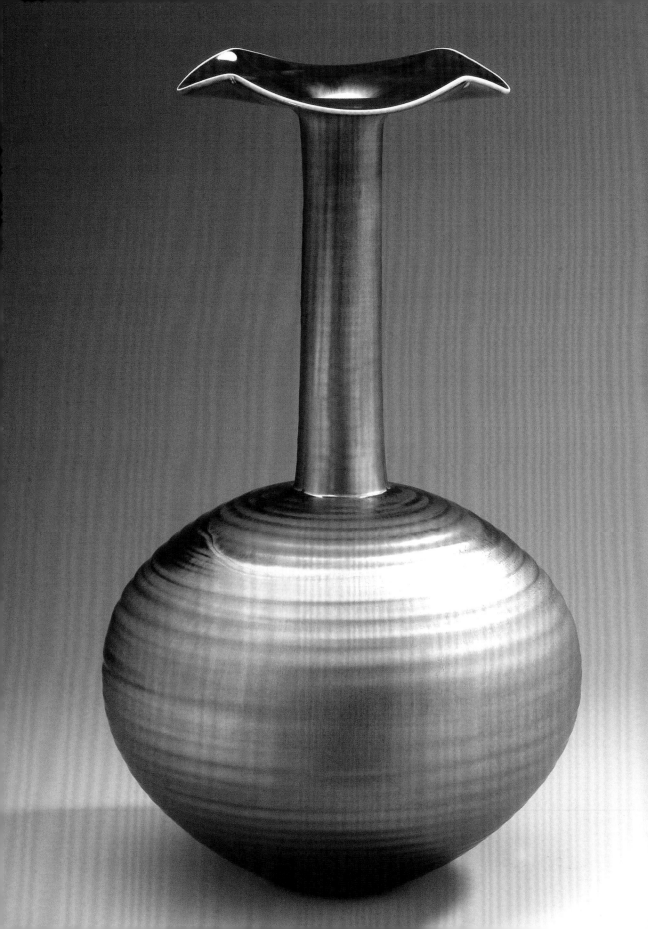

6 Glazes for porcelain

The glazes we see on the porcelain wares for our daily domestic use tend to be ubiquitous, and at best could be described as shiny and hygienic, hard and durable. So it comes as a complete revelation to see for the first time the ceramic collections in our great museums, or to look at the variety and ingenuity of the work of contemporary ceramic artists.

We will see that the glazes which are integral to ceramics are not just a simple outer covering but are something that imparts a whole range of characteristics which enhance the subject and imbue it with layers of visual and emotional meaning. The body and the glaze should be considered a single entity. The surfaces can evoke memories of jade, polished stone, ivory and jet, can feel like silk or make one think of running water or blue sky.

The beauty of porcelain glazes, and one of the main factors which make the subject so beguiling, is the colour response only achievable on a pure white body. From 'barely there' whispers of blue and celadon to the luscious depths of copper red, any colour seems possible. Basically, most stoneware glazes can be used for porcelain, with sometimes a slight adjustment for shrinkage. Moreover, the intrinsically beautiful stoneware glazes with their subtle, quiet hues can appear more alive and achieve more depth on a white body as they appear to be lit from within.

LEFT: Hideaki Miyamura (Japan), *Blossom with Gold Glaze*, 2012. Wheel-thrown and altered, fired to Cone 12 in reduction, H: 61cm (24in) x D: 25cm (10in). *Photo: Dean Powell.*

RIGHT: Jeanne Opgenhaffen (Belgium), *Power of Running Water* (detail), 2008. Blue-stained porcelain, 2.20 x 1.5m (86½ x 59in). *Photo: courtesy of the artist.*

Of course, porcelains and, consequently, their glazes were the last great development in the history of ceramics. Since the production of high-fired porcelain became organised in Tang Dynasty China (618–907 CE), it has been inevitable that many of these wares and those of subsequent dynasties would survive to the present day. They provide the basis for our study and a source of inspiration. Even so, it is interesting to consider the wider history of glazes so that we can trace the development of the various types and categories, and perhaps adapt them for current use on porcelain.

Archaeological and scientific fields of research continue to expand our knowledge of glazes. It appears that the earliest glaze technology developed in several different geographical locations in antiquity, and that each was distinctive, depending on culture, the differences in local mineral compositions, and kiln technology. The new ceramic practices and goods then spread far and wide along the established trade routes.

The prehistoric mining communities of Europe developed the use of metals, notably copper. From the third millennium BCE, coloured quartz-frit pastes were used by ceramicists in the Mediterranean (the practice having probably originated in Mesopotamia in the 6th–5th millennia BCE), from where the technology spread to Egypt and Syria.

Some of the earliest-known glazed wares are beads and small objects found in graves of the Predynastic period in Egypt and known as Egyptian faience or paste. They were formed as alkaline mixtures of crushed quartz or sand, with little or no clay, and were usually coloured with traces of copper. The soluble salts migrate to the surface during drying and form a primitive glaze at low temperatures of under 950°C (1742°F). The colour is characteristically a vibrant alkaline turquoise blue, which can be recreated today using barium in high-fired porcelain glazes.

Simple glaze technologies in Mesopotamia and Babylonia were also developing and by the end of the 2nd millennium BCE there are glazed tiles with several different colours. By 575 BCE we have the spectacular soda-glazed tiles forming the walls of Babylon. The Ishtar Gate, seen in the Pergamon Museum in Berlin, was one of eight in the city, so here we see ceramics being used on a major architectural scale, just as, in Chapter 5, we saw contemporary porcelain walls and panels forming art installations in public buildings.

A leap in kiln technology took place independently in China. The first glazed proto-porcelain, dating from the Shang Dynasty c.1700–1027 BCE, was excavated in 1929 at Anyang in Henan province. One fine vessel with stamped decoration is coated with a fluid, shiny, treacle-coloured glaze which has pooled towards the foot. During this time high-fired wood-ash glazes that were lime-rich and low in potash were fired to temperatures of over 1200°C (2192°F). These wares were produced up to as late as the Western Han period (206 BCE–24 CE).

By the end of the 1st millennium BCE and into the Roman period, low-temperature alkaline and lead glazes were being used around the Mediterranean and the Middle East. Lead glazes were also used in Han Dynasty China (200 BCE–200 CE) and with great artistry in the Islamic world. Lead decays and many of these wares have degraded to a pearly iridescence, the surface of which can be an inspiration to today's artists, able to reproduce these effects using metallic overglaze lustres.

Low-fired tin glazes were developed in the late 8th and 9th centuries and were used extensively throughout Europe for several hundred years. They were made to imitate Chinese porcelain for several centuries until the secret of hard-paste porcelain was discovered in 1707.

As we have seen in Chapter 1, Chinese porcelain styles proliferated in northern and southern kilns from the Tang Dynasty onwards, with parallel developments in glaze technology. Southern styles included the lime-alkali glazes used in the early 10th century, which used limestone rather than wood ash as the main glaze flux. The later Song Dynasty translucent lime glaze known as *qingbai* was used from the 10th to the 14th centuries. The glaze ash-plus-porcelain stone mixtures of the 14th century became a standard glaze over cobalt painting, and the *shufu* glazes with much diminished glaze-ash content were perfect over carving as seen on press-moulded bowls.

In the northern Song dynasty (960–1127 CE), outstandingly beautiful glazes are seen on *ding* wares. These beautiful creamy-white glazes were clay and magnesium-rich and were fired in an oxidised atmosphere.

The glazes for Jun stonewares are described as 'optical' because the mass of trapped bubbles they contain refract the light, giving the glaze great depth and subtlety. The glazes are of the lime-alkali type. The colouring depended on iron and titanium. These glazes have been much researched and are of great interest to contemporary ceramic artists.

Spittoon, China, Northern Song, ding ware, 10th century. D: 15.9cm (6¼in) x H: 8.9cm (3½in). *Photo: ©Victoria & Albert Museum, London.*

101

LEFT: Funerary jar (to contain grain), China, Southern Song, 1127–1279. Longquan glaze, H: 25.5cm (10in) x D: 12cm (4¾in). *Photo: © Victoria & Albert Museum, London.*

Of all the glazes developed in southern China perhaps the most dramatic is the Song Dynasty (1127–1229 CE) *Longquan* celadon. These classic glazes of the late 12th and early 13th centuries imitated jade and varied in colour from duck-egg blue to sea green to grey-green, and were applied thickly, possibly in several different layers, to a thick porcellaneous body.

SOME GLAZE TYPES

Reduction glazes

Reduction-fired glazes are much loved by ceramic artists as they can give an extra depth and richness and bring out characteristics that would be hidden in an oxidised firing. However, results are never guaranteed and the experimental element has to be accepted.

RIGHT: Hideaki Miyamura (Japan), *Vase with Three Glazes*, 2010. Fired to Cone 12 in reduction, H: 48cm (19in) x D: 20cm (8in). *Photo: Dean Powell.*

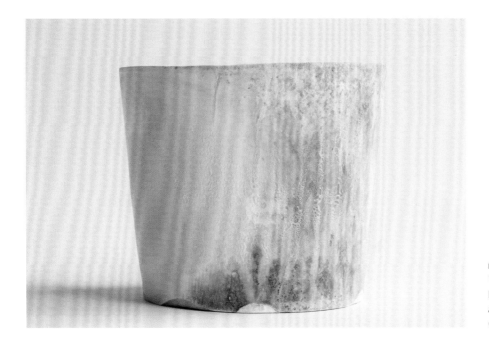

LEFT: Taro Tabuchi (Japan), *Vessel*, Yohen (accidental) Hakuji, 2011. Wood-fired, fly ash over clear glaze. *Photo: © Panorama.*

Ash glaze

Wood ashes consist of calcium- and potassium-rich compounds, as well as small amounts of silica, magnesia, phosphate and other oxides and carbonates, and can have subtly distinctive colouring effects depending on the type of wood. This is especially beautiful on white porcelain bodies fired in reduction. Natural fly ash in a wood-firing kiln can form an incidental glaze on the shoulders of pots.

Copper red

It is rewarding to study the historic examples of copper red in museum collections (such as those in the Percival David Foundation, located at The British Museum) as they vary in colour so dramatically, and will give you a good idea of what is possible, from palest pink to peach, to rich red, to deep oxblood or liver colour.

Copper is easily volatilised during firing, so results can be elusive. Re-oxidised areas revert to green. The richest reds usually have a glassy texture, with some depth, showing what's known as *phase separation*, the optical qualities arising from the microstructure of the glaze. There will probably be bubbles and craze lines and usually some pinholes. As little as 0.5% copper oxide will give a good red in combination with tin oxide.

RIGHT: Justin Teilhet (USA), *Untitled*, 2013. Copper red in reduction. H: 53.5cm (21in). *Photo: Justin Teilhet.*

FAR RIGHT: Vivienne Foley, *Sinuous Vase*, 2011. H: 39cm (15½in). *Photo: © VF.*

Celadon

Celadons can vary considerably in colour and are achieved with the addition of small amounts of iron, sourced as either red or black iron, or yellow ochre; 0.5% will give pale green in reduction. Celadon glazes show yellow where re-oxidised. Slow firing and cooling, with quite heavy reduction for an hour before maturation, is commonly practised.

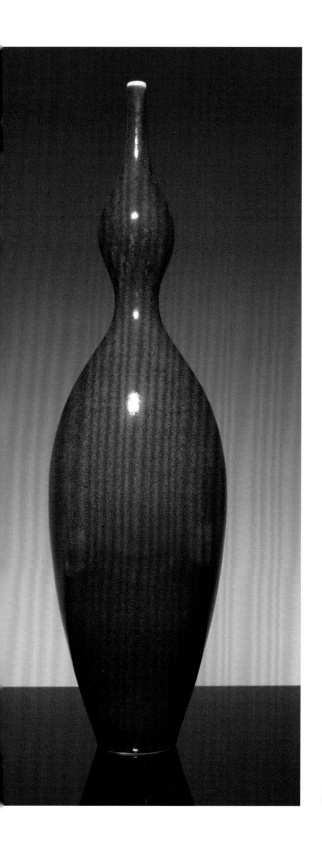

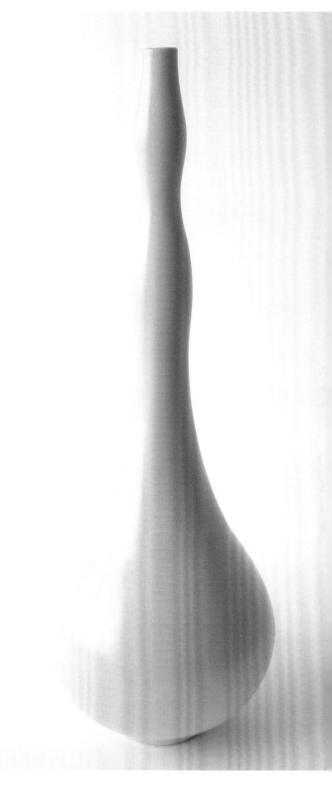

Tenmoku

Tenmoku glazes give rich browns to blacks, developments of which are the 'hare's fur' and 'oil spot' effects. Containing up to 8% iron oxide, they are generally considered to be oxidised glazes, but especially beautiful red tinges can be achieved in reduction, further enhanced with brushed-on iron or manganese overglaze, or with small additions of bone ash in the glaze.

Oxidised glazes

Oxidised firings, especially in electric kilns, give a clean and controllable atmosphere in which to fire porcelain. Reduction glazes can also be fired in oxidation, giving different results. The use of glaze and body stains, as well as basic oxides and materials such as barium will give an infinite choice of colour.

Crystalline glazes

Crystalline glazes give spectacular effects and require specialised firing and finishing. They can be fired both in oxidation and reduction. Recipes can be found from cones 6 to 10. These glazes are highly glassy and fluid and typically contain 25% calcined zinc oxide. The zinc-silicate nuclei or seed crystals grow into dramatic crystal formations as the kiln temperature is held for up to three to five hours at the stage where the molten glaze is on the verge of solidifying.

The wares must be set on specially made cups to catch the running glaze, and the foot rims must be ground clean with grinding equipment to finish.

BELOW: Chris Keenan (UK), *Teapot and Beaker* (set), 2013. Tenmoku glaze, (teapot) H: 23.5cm (9¼in); (beakers) H: 10cm (4in). *Photo: Michael Harvey.*

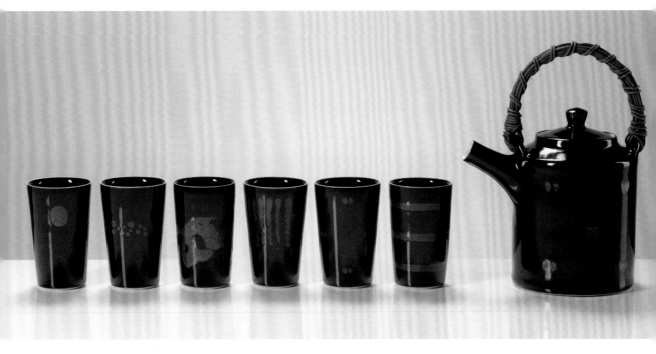

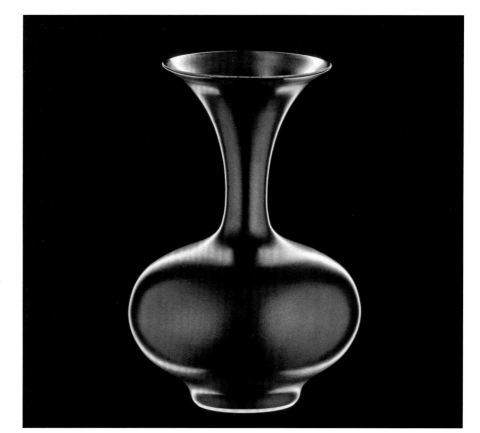

RIGHT: Vivienne Foley, *Vase*, 1987. Black magnesia glaze, H: 19cm (7½in). *Photo: Geoff Smyth.*

BELOW: Bill Boyd (Canada), *Crystalline Glaze Vase*, 2013. 'Dark Star' glaze with 24-carat-gold accents, H: 36cm (14in) x D: 46cm (18in). *Photo: courtesy of the artist.*

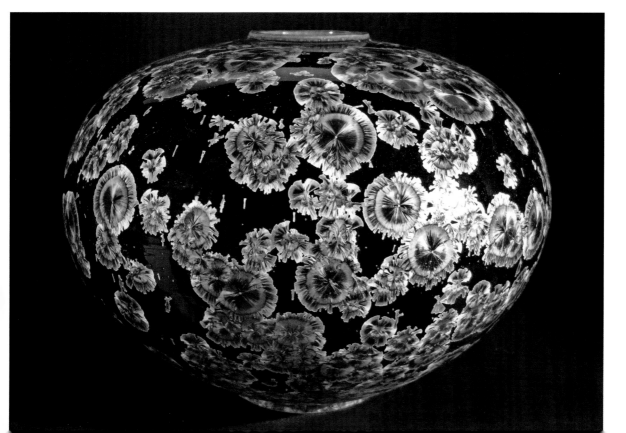

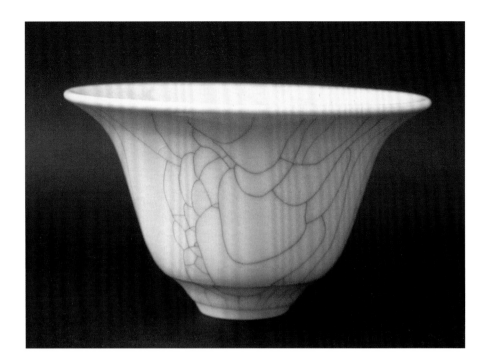

Christine-Ann Richards (UK),
*Crackle Bowl. Photo: courtesy
of the artist.*

Crackle glazes

Whereas crazing is normally seen as a fault, the effect in crackle glazes is deliberately exaggerated. A high coefficient of expansion is aimed for with the addition of high amounts of potash or soda, and perhaps a slightly higher firing temperature. On porcelain it is easier to achieve a crackle glaze with a glassy glaze rather than with a matt one, and it also makes the craze lines easier to stain.

Several styles were developed on stonewares in Song Dynasty China, including the beautiful wide 'crab claw', and the more complex 'golden thread and iron wire'. In the case of the latter, wares just out of the kiln were stained and after a secondary network of lines had developed they were stained again in a contrasting colour.

It must be admitted that crackle glazes are generally more suited to stoneware bodies than to porcelain, not least because the glaze coat needs to be very thick, and a thin-walled porcelain vessel is likely to be weakened and therefore unsuitable for domestic use. However, visually this glaze type is beautiful.

Barium glazes

The addition of barium carbonate to a glaze of over 20% makes a matt glaze with a soft sheen. The colour response possible with barium is the main reason for using it. In oxidation a strong turquoise is achieved with copper, while chrome, vanadium, iron and cobalt will all give brilliant colours. **However, barium is toxic and therefore not safe for food vessels.**

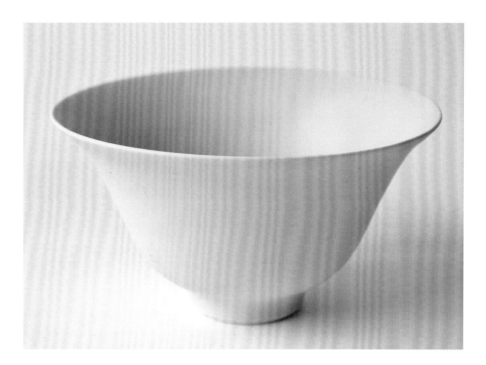

Vivienne Foley, bowl, barium and copper glaze, D:15cm (6in). *Photo: © VF.*

Salt or vapour glazing

Salt or vapour glazing is a technique possible only in live-flame kilns whereby the glaze is formed on the bare pots by introducing sodium into the firing chamber towards the end of the firing cycle. In the UK salt glazes are historically associated with 19th-century utilitarian stonewares, but interesting effects with colour and texture are possible on porcelains, as Jack Doherty shows with his work of recent years. See also Chapter 7.

RESIST, SGRAFFITO AND SLIP-TRAILING

Decorative effects can be made by manipulating freshly glazed surfaces. Wax resist painted under or over the glaze can give subtle effects. The waxed areas can be gently sponged, or further layers of glaze sprayed over. Latex resist can be painted over glaze, further layers of glaze can be sprayed or dipped, then the latex peeled off. This can cause ragged edges, which can be either treated as part of the decorative effect or smoothed over with a finger.

Sgraffito

Sgraffito, best known as a Renaissance painting technique, has been adapted by ceramic artists. A method of scribing a pattern through the glaze or slip layer, it is best done when the glaze is still slightly damp.

Slip-trailing

White or coloured clay slip the consistency of double cream can be drawn into a slip-trailing bulb and used as a drawing tool. The lines are likely to be slightly raised on the finished wares. The slips can be enriched with a small amount of base or transparent glaze to change the shrinkage and texture.

Slip glazes

Slips made from the body material and screened through 120 mesh to a slop the same consistency as glaze can be coloured with body stains, in additions of 10–18%, and dipped or sprayed. These slips can be left unglazed or covered with further layers of glaze.

It is much easier to wet down turnings from the wheel than from a lump of plastic clay. Non-throwers should let clay dry out completely and crush to a powder inside a plastic bag. It is also possible to make a good matt slip by mixing a body slop and a made-up glaze slop together 50:50 by wet weight.

As long as the shrinkage rates are similar, a plastic off-white body can be covered with slip or engobe made from a whiter porcelain body and polished at bisque then fired from 1200°C (2192°F) upwards.

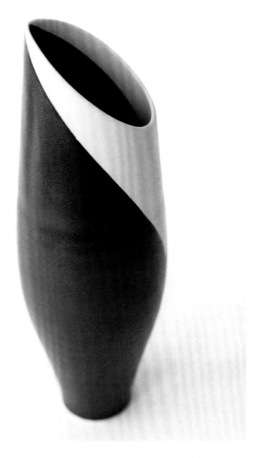

Vivienne Foley, *Sixties Vase*, 2000. Black and white glazes using latex resist, H: 31cm (12¼in). *Photo: © VF.*

Reactive slip

I have made a reactive or 'volcanic' slip by adding 40g (1oz) of silicon carbide (screened through 220 mesh) to 630g (1lb 6oz) of porcelain slip, coloured with oxide or otherwise. Silicon carbide sinks in a spray gun and can block it, so it is better to brush it on to bisqueware and then to paint on the colouring oxides. For instance copper gives turquoise, and vanadium – **NB This is toxic** – gives yellow. Silicon carbide can give localised reduction effects.

These slips are generally experimental, so if you are going to make a further glaze coat to go over them, it is best to spray as dipping will pollute your glaze bin.

Metallic slip

Metallic slips are not suitable for domestic wares. When they come out of the kiln they are bright bronze and gold-coloured but will tend to dull down as they oxidise over time. Slips can be brushed onto bisqueware or over unfired glaze. Care must be taken as they are extremely fluid at high temperatures, so it is best to use them to

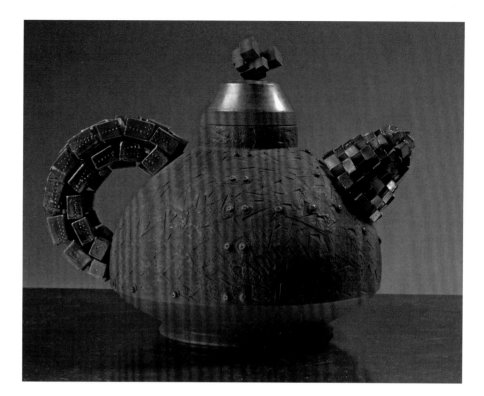

Dean Smith (Australia), *Red Series Teapot*, 2010. Superior white porcelain, engobes, clear glaze, platinum and gold lustre, fired to 1260°C (2300°F) and then 760°C (1400°F), H: 14cm (5½in) x W: 20cm (8in). *Photo: Julie Millowick.*

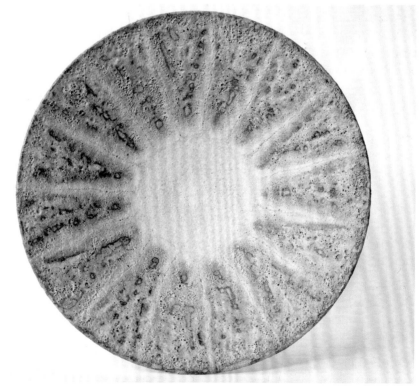

Vivienne Foley, *Star Bowl*, 1994. Vanadium stain over silicon carbide slip, D: 30cm (12in). *Photo: © VF.*

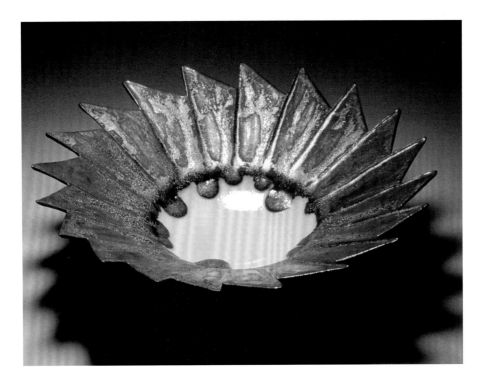

Vivienne Foley, *Bowl with Bronze Slip*, c.1994. Thrown and carved, D: 23cm (9in). *Photo: © VF.*

emphasise a rim or the inside of a bowl. The concentration of heavy particles can also block a spray gun.

Try seven parts manganese dioxide, three parts red clay or yellow ochre, and one part copper oxide.

COLOUR IN GLAZE

Underglaze colours

Underglaze colours are usually applied, either raw or mixed with a medium, as painted decoration on greenwares as they fuse to the body to a certain degree and are less likely to smear when dipped in glaze. Applications to the bisque can be easier to correct but it is safer to spray the glaze coat. Commercial colours, which come in a wide range, are intermixable and can also be adjusted with careful additions of basic oxides.

Glaze and body stains

The basic raw pigments, oxides, dioxides and carbonates, such as cobalt (which is particularly strong), copper, chrome, manganese and the irons, can be used as glaze and body stains. They are all strong colourants and will need further grinding and washing through a fine 200-mesh screen.

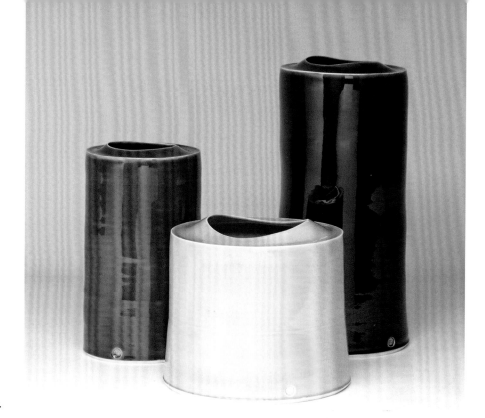

Tanya Gomez (UK), *Group of Three*, 2012. Fired to 1280°C (2336°F). Electric and reduction firings, max. H: 33cm (13in), max. W: 19cm. *Photo: Simon Punter.*

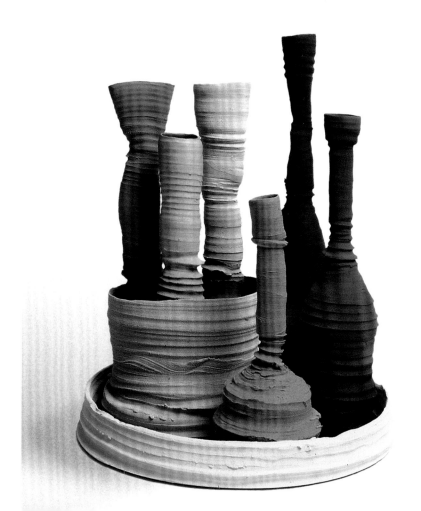

James Makins (USA), *Momo*, 1995. Thrown forms. *Photo: Yasuhiro Yamaoka.*

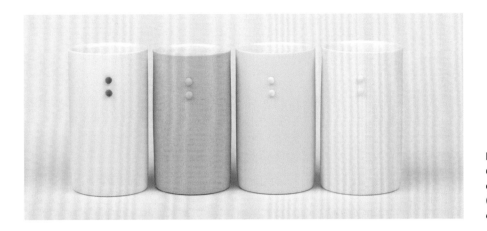

Lee Ka Jin (Korea), *Pastel Cups*, 2011. Stained bodies, oxidised firing, H: 12 x 7cm (4¾ x 2¾in). *Photo: courtesy of Gallery LVS, Seoul, Korea.*

Commercial stains – which are synthetic, fritted pigments made from the basic raw materials, and therefore more consistent – are usually added to glaze or body in additions of 5–8%.

Overglaze enamels and lustres

Porcelain with its pure white body is especially suitable for the application of overglaze painting or screenprinting. Overglaze enamels and lustres are made commercially in a very wide range of colours. They must be mixed with a medium to facilitate painting, and the wares must be given a third firing at a low temperature of 730–800°C (1346–1472°F). They are considered hazardous and must be handled with care. They will give off fumes below 500°C (932°F), so good ventilation of the room is needed.

Metallic lustres also come in a good range of colours. They can be sprayed or brushed on, and decorative effects can be made by breaking the surface tension with a brush point moistened with turpentine (See also Chapter 5, p.94).

BELOW LEFT: Chinese, Late Kangxi, 1608-1700. Brush pot with overglaze enamels, H: 16cm (6¼in) x W: 18cm (7in). *Butler Family Collection. Photo: © VF.*

BELOW RIGHT: Custard cup and saucer, Spode Ceramic Works, Stoke-on-Trent, 1815–20. Enamel and gilt, H: 7.6cm (3in) x D: 8.3cm (3¼in). *Photo: © Victoria & Albert Museum, London.*

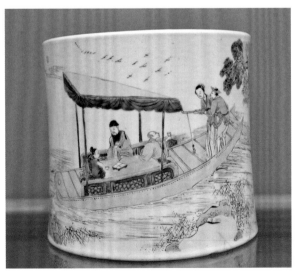

Dean Smith (Australia), *Ice Blink*, 2011. Porcellaneous stoneware, engobes with matt crystalline glaze and platinum lustre, multiple firings to 1260°C (2300°F) and 760°C (1400°F) in oxidation, H: 10cm (4in) x W: 30cm (12in). *Photo: courtesy of the artist.*

Justin Teilhet (USA), *Group*, 2013. Gunmetal glaze with 24-carat gold leaf, max. H: 45¾cm (18in). *Photo: courtesy of the artist.*

IN THE STUDIO

We are beguiled by surfaces, and when it comes to glazing there is a glorious choice of textures and colours to fire the imagination, but glaze should always be part of the original concept rather than an afterthought at the bisque stage.

Most ceramic artists experiment with published recipes and proceed to adjust them for their own circumstances, before formulating their own.

The main points to remember when designing your own glaze are as follows:

- All glazes are made up of silica, alumina and flux
- Silica is the glass former (quartz, flint)
- Alumina stiffens the glaze (clay)
- Flux determines the temperature at which the glaze melts. (feldspar, Cornish stone, nepheline syenite, whiting, dolomite – which is a secondary flux).
 (*See also* Chapter 3.)

Further additions such as colouring oxides and opacifiers lend the glaze character.

- Colouring oxides. (primarily manganese, copper, chrome, cobalt, iron)
- Opacifiers (titanium, tin oxide, zinc).

Glaze fit

Many published glaze recipes for high-fired wares do not differentiate between stoneware and porcelain, so when it comes to developing a stoneware glaze for porcelain you may think there is no obvious difference, apart from the colour response, as the firing temperatures are in the same range. However, it may be necessary to adjust recipes to fit specific bodies as most stoneware glazes will craze to some extent on porcelain. This is because porcelain bodies tend to be low in silica and rich in fluxes, with both features encouraging crazing in glazes. A further factor is that porcelain bodies usually have smoother surfaces than stoneware and so glazes do not 'key' into the porcelain surface to quite the same extent as with stoneware.

The fundamental difference between translucent porcelain bodies and stoneware bodies is that porcelain bodies are generally based on china clay whereas stoneware bodies are generally based on ball clays and/or fireclays. These have significantly higher levels of free crystalline silica. Hyplas 71 ball clay, for example, has about 40% crystalline silica; china clay has less than 5%.

It is the free silica content that largely determines the inherent craze resistance of a clay body and the amount is regulated to give the desired thermal shrinkage at the body's maturing temperature. But with porcelain bodies you begin to get significant glass formation at high temperatures and this begins to cause the free silica to combine with other materials to form silicates. Now, free crystalline silica has a high thermal expansion but silicates have low thermal expansion. With stoneware bodies, firing slightly higher is a classic way of resolving crazing problems because it increases the thermal expansion/shrinkage rate of the free silica in the body. This is true to a

certain extent with porcelain, but once the free silica begins to be taken into a glaze solution to form silicates then thermal expansion/shrinkage goes into reverse. Slightly overfiring can therefore increase crazing with porcelain bodies.

As we have learned some of the raw materials which form the body will be included again in powder form in the glaze recipe, so the interface between body and glaze is integral to the piece as a whole. To recap, the porcelain body when fired to maturity is vitreous and almost glassy. A high-fired glaze is closely related and meshed to the body in terms of materials and vitrification. However, with porcelain this will not necessarily guarantee 'non-crazing' if the glaze's expansion co-efficient is still too high.

Coefficient of expansion is a term that describes the small change in length or volume that all ceramics undergo in heating, and cooling to about 300°C (572°F), once they have already been fired. Thus a 'high expansion' body is also one that shrinks usefully in the last 300°C (572°F) or so in cooling. The actual shrinkage is minute, but it can be enough to put the now-solid glaze into compression, thereby avoiding crazing. High expansion bodies tend to be low in fluxes and rich in fine silica, with industrial earthenware being a particularly good example.

A high-expansion glaze will have a corresponding high shrinkage in cooling, so will tend to craze on most bodies. Thus, to achieve the perfect marriage it will be necessary to make adjustments to one or both. It is usually easier to make adjustments to the glaze.

Glazes can be made to 'fit' (avoid crazing) by a number of means, usually by raising their silica contents by a few per cent, with respect to their fluxes. In practice, though, this is easier said than done, and it can be surprisingly difficult to prevent a porcelain glaze from crazing and still preserve its character. Nevertheless, changing feldspar for Cornish stone, replacing a few per cent of whiting with talc or calcium borate frit can sometimes do the trick. In oxidised glazes some whiting can be swapped for zinc oxide. High feldspar glazes, however, will craze on most bodies and are a prime way for making 'crackle' glazes - i.e. high-expansion glazes which give interesting crazed results in cooling.

Always remember the respective thicknesses of body and glaze will have a strong bearing on the aesthetics and the mechanical strength of the wares, and also their resistance to thermal shock. If the glaze layer is very thick and the body wall is very thin the glaze is likely to craze, either immediately or over time or if exposed to boiling water.

Making up a glaze recipe

When making up a glaze recipe with dry materials, follow the initial procedures for making a porcelain body (see Chapter 3). The consistency of single cream is usually right for both dipping and spraying. This can be recorded with a hydrometer if you need accuracy in subsequent batches, or by dipping a bisque tile before proceeding to glaze the wares. Being able to determine how the glaze slop feels when you stir the bin, as well as knowing the optimum thickness for various glazes, is something which will come with experience.

It is always easier to store the glaze slop slightly too thick, then add water when you are ready to use it. If you mix it up too thin, you will have to wait for hours until it

has settled enough to enable you to pour off any surplus water. Always store the glaze slop in an airtight bin to prevent evaporation.

Glazes tend to settle even as you are working with them, so always stir before filling the spray gun or dipping. Some glazes will settle rock hard over time, so you'll need to add a few drops only – but no more than that, as over-addition can also cause settling – of a commercial deflocculant or 1% of white-firing bentonite mixed in hot water.

Methods of glaze application

Fundamentally, there is no difference in glazing techniques between stoneware and porcelain. However, the tradition of raw glazing is less common in porcelain because thin-walled pots saturate too quickly and the glaze can run off. In order to overcome the same problem bisque pots can be heated in the kiln to 100°C (212°F) and handled with gloves before the vessel is filled with glaze and quickly rotated to cover the insides. The wares are then dried and reheated before the outsides are dealt with.

Because porcelain is often on a relatively small scale and usually requires a serene and uniform glaze which is not interrupted with runs or uneven thicknesses, something which is almost inevitable with dipping and touching up, I find it is preferable to apply the glaze by spraying.

Spraying

There are a few rules to abide by when spraying:

SAFETY FIRST: By law kilns must be fitted with an automatic cut-off from electricity supply when the door is opened, but check. Always wear gloves and a face mask.

Spray guns

Spray guns are notoriously prone to blocking, which causes splattering and lumpy finishes. Be meticulous in cleaning all the parts after use. Don't be surprised if you have to strip the gun during a glazing session, and make sure when filling the reservoir that there is no air lock.

Bowls

- **The inside:** Take the hot bowl from the kiln. Place on the turntable and spray the inside, making sure the rim is also covered with glaze. At the slightest sign of saturation place back in the kiln to reheat.

- **The outside:** Take the hot dry bowl from the kiln and suspend over the turntable, making sure the rim is free. For the support a cylindrical form of the correct height is ideal, with a thin piece of foam resting on top to protect the glazed inside of the bowl.

- Spray the rim with the first glaze layers as this area will cool and thus saturate quickly, and then work down from the foot to the rim, covering to the intended thickness, which can be judged by pricking with a needle.

- Trim the glaze from the foot ring with a scalpel, sponge clean while the glaze is still slightly damp, and set aside to dry.

Hollow forms

It is important to keep the rim of the pot free of the turntable as glaze spray from the gun gathers quickly into a thick crust.

- **The inside:** Pour the glaze as described below (see 'Dipping').

- **The outside:** Follow the same routine as for bowls (inverting the form when possible), concentrating on the thin rim first, then the first few inches down from the foot ring. Then, if the form begins to saturate, clean the foot ring and reheat. Lastly, place the piece directly on the turntable and complete the glazing, avoiding the foot ring.

- Trim and clean the foot ring as before.

- Always be careful not to oversaturate the vessel when spraying as this can cause the glaze to crawl during the firing.

Dipping

- It is necessary to have quite a large bin (at least 3kg/6.6lb mix) of glaze of the right consistency for dipping wares.

- Depending on the thickness of the walls, it is probably best to warm the vessel in the kiln first. Pour the inside up to the brim and either pour out to one side or rotate as you pour. Let the ware dry completely, then warm it before plunging the piece into the glaze up to the rim, supporting the ware from the inside without touching the rim. Leave this to dry and then touch up the rim with a paintbrush.

- Flatware can be plunged into the glaze with the aid of a glaze claw.

- Rims and foot rings will need to be sponged and touched up.

Tools to keep near the turntable

- A damp sponge

- A needle or scalpel, used to test frequently for thickness.

Glaze recipes

Materials by percentage in high-fired glazes

A useful guide to the upper limits of materials commonly used in glazes maturing in the Cone 9 to 11 range was described by Daniel Rhodes, as follows:

| 70% of glaze: | Feldspar | 50% |
| | Silica | 20% |

30% of glaze:	Clay	0–15%
	Whiting	0–15%
	Barium carb	0–10%
	Magnesium	0–10%
	Dolomite	0–15%
	Talc	0–15%
	Zinc	0–5%

Wood ash (lime)

Apple wood crackle glaze; reduction Cone 9

Soda feldspar	Whiting	Flint	Apple wood ash
80	9	8	6

Rose red ash glaze; oxidised Cone 9–10

Potash feldspar	Whiting	Flint	Ash tree ash	Tin oxide	Potterycrafts Amulet Green Stain 4137
48	42	42	36	19	10

Copper red

Nigel Wood Xuande red; reduction Cone 9

Potash feldspar	China clay	Quartz	Whiting	Bone ash	Copper carbonate
52	10	25	12.5	0.5	0.4

Feldspathic glazes

Rhodes Cornish stone crackle glaze; reduction Cone 10–11

Cornish stone	Whiting
85	15

Rhodes opaque glaze; reduction Cone 10–11

Soda feldspar	Whiting	Ball clay	Bone ash
80	10	10	2

Guan glaze; reduction Cone 9

Potash feldspar	Whiting	Mixed wood ash
81	26	6

Barium glazes

Oxidised Cone 9 (not food-safe)

Potash feldspar	Flint	Barium carbonate	China clay	Whiting	Dolomite

55	10	20	5	12	5

Oxidised Cone 9 (not food-safe)					
Nepheline syenite	Flint	Barium carbonate	China clay	Dolomite	
70	10	20	10	5	

Crystalline glazes

Oxidised Cone 8–9					
Ferro frit 3110	Calcined zinc oxide	China clay	Silica	Rutile	Colouring oxide
48	28	1	18	5	0.5–2%

Clear glazes

VF shiny transparent; oxidised Cone 8–9					
Potash feldspar	China clay	Whiting	Flint	Zinc	
156	90	114	228	12	

Takeshi Yasuda transparent, satin; oxidised Cone 7 (1235°C/2255°F)					
Cornish stone	Wollastonite	China clay	Talc	Petalite	
48.6	37.7	6.4	3.2	3.2	

Tenmoku glazes

Tenmoku; reduction Cone 10					
Potash Feldspar	China Clay	Whiting	Flint	Iron Oxide	
72	7	13	8	12	

Tenmoku; oxidised or reduced Cone 9					
Potash Feldspar	China Clay	Whiting	Flint	Red Iron Oxide	
66	8	12	12	9	

Magnesia glazes

Oxidised Cone 9					
Potash Feldspar	China Clay	Talc	Whiting	Quartz	Titanium
69	66	69	39	66	30

7

Firing porcelain

In the Far East, "Can I visit your kiln?" is a question more likely to be asked than "Can I visit your studio?" It makes every sense, too, for without kilns there can be no ceramics.

There are several designs of kiln in common use (updraft, downdraft, muffle), fired with a variety of fuel (wood, coal, oil or gas for live-fire kilns) or with electricity for oxidised firings. None is specifically designed for the firing of porcelain, but the same kilns and firing conditions used for stonewares can lead to very different results with body and glaze.

In historic times two main types of kiln were developed in China, again following the north/south divide described in Chapter 2. In the north the *mantou* or 'steamed-bun' kiln (the name echoing its shape) was fired with coal in an oxidised atmosphere up to 1300°C (2372°F) to produce the *ding* porcelain wares, and many northern blackwares. They were also fired in reduction for *yaozhou*, *ru* and *jun* wares. Kilns with stepped floors produced *blanc de chine* wares at Dehua in Fujian.

In the south during the Warring States period (475–221 BCE), some of the earliest proto-porcelains were produced in kilns 6m (236ft) long with side-stoking ports which reached temperatures of over 1200°C (2192°F).

These climbing kilns known as Dragon kilns fired the pine wood available in abundance alongside the natural supply of porcelain stone. (By the mid-Ming period the dragon kilns at Jingdezhen had been phased out and most of the imperial wares were produced in double-gourd kilns or egg-shaped kilns.) Dragon kilns were built up the side of a hill, with a single chamber sometimes 60 metres (197 feet) long. Porcelain wares by the tens of thousands were protected from fly ash by being packed in saggars stacked in serried ranks throughout the kiln.

LEFT: Michael Flynn (Ireland/ Poland), *Forest Tales*, 2012. Four reliefs, slipcast, manipulated, assembled porcelain with transparent glaze, fired to 1380°C (2516°F), (overall) H: 133cm (52¼in) x W: 101cm (39¾in) x D: 15cm (6in). *Photo: Grzegorz Stadnik.*

RIGHT: Taro Tabuchi (Japan). Anagama wood-fired kiln, Takamatsu City, Japan. *Photo: © Panorama.*

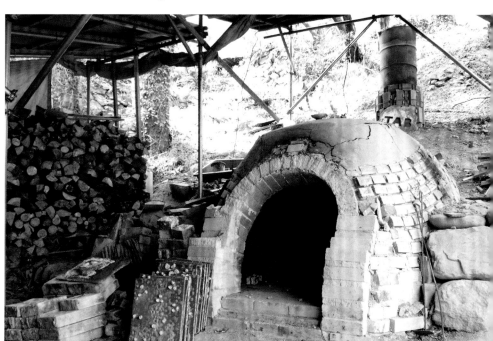

The firebox was at one end, the atmosphere controlled by the adjustment of dampers. The firings took place over several days of continuous stoking and consumed anything up to 15 tons of pine wood.

These kilns reached their heyday in the Song Dynasty (960–1279 CE), but the technology had previously spread to Korea and thence to Japan in the 5th century, and were known as anagama or cave kilns.

When I first visited China in the mid-seventies our hosts did not want us to see dragon kilns, preferring to emphasise their modern, factory-sited, oil-fired kilns. Thankfully the Chinese have come to appreciate their amazing heritage, and some ancient kilns have been restored (or are being built anew) in China, at Jingdezhen, and also in the case of the Nanfeng kiln, Shiwan, in Fushan province.

Anagama kilns have an undoubted appeal for many contemporary potters, especially in Japan, Australia and the USA among those who are determined to preserve the ancient techniques of kiln building and firing, and to experience the primal excitement of heat, flames and exhaustion as a communal experience.

The new anagama kilns resemble upturned boats constructed of bricks. The weather affects the firing, with high or low pressure altering the quality of the flames so that, as with steering a boat, constant decisions have to be made, in this case with the management of vents and stoking. A 6-metre (19½ ft) kiln will take at least 18 hours to achieve porcelain temperatures, and three days to cool down.

Kiln technology can be an end in itself, with the pots more likely to be the rustic kind rather than exquisite porcelains. It is a shame that more contemporary makers working in porcelain do not have the opportunity to explore the possibilities of wood firing. The experience of committing pots to the kiln, feeding the fiery beast and waiting to see what the kiln gives back is very rewarding; the random effects of glaze, colour and texture so beloved of the aficionados of Bizen and Shigaraki kilns would certainly be exciting to see on a white porcelain body. One who has done just this is Japanese potter Taro Tabuchi, whose porcelains have great warmth with their quietly considered forms and subtle texture and colouring.

Indeed, pine wood is relatively high in potassium and calcium and can produce attractive coloured flashes, along with texture caused by fly ash falling on the shoulders of unprotected pots, especially near the firebox.

Taro Tabuchi (Japan), Three bowls, Yohen (accidental) Hakuji, 2011. Fired in an Anagama wood-fired kiln, fly ash over clear glaze. *Photo: © Panorama*

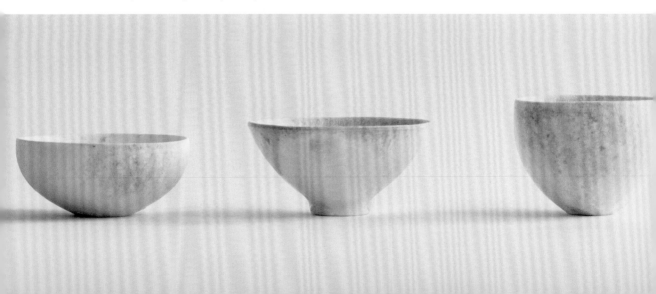

These exciting and robust enterprises make the production of ceramics a complete and rounded experience, and serve to separate the men from the boys. However, many of the rest of us will have to make do with the somewhat anaemic alternative of an electric kiln in an urban environment, the advantage being that our energies can be spent in perfecting technique and design.

KILN TYPES

Electric kilns

Electric kilns provide the cleanest and simplest way of firing for the majority of potters. They can be either front- or top-loading. The electric elements will degrade over the course of many repeated firings, depending on load and heat work, and will need to be replaced – sometimes singly, sometimes as a set – which is an expense you will need to factor in to the price of your pots. Manufacturers will not give an average lifespan, but I would expect an average set of elements to make at least 25 firings.

Pyrometric controllers now come as standard in most kilns and the firing can be programmed from start to finish with three ramps or stages: 1. to bisque; 2. to glost; and 3. the down ramp to cool.

Top loaders

Top loaders are lighter and more suitable for small spaces but are somewhat more difficult to load. They can be less well insulated than front loaders and will therefore cool down faster, which can have an effect on the glazes unless the down ramp is controlled.

The top-loading kilns manufactured in the UK are generally designed to fire to a maximum of 1300°C (2372°F), and if under approximately 3 cu.ft capacity are designed to run on a single phase (an electric cooker circuit). Any greater capacity will require special wiring for a three-phase supply.

Front loaders

Front loaders are preferable where space and access are not a problem. They have the same electrical-circuit requirements as the top loaders. They are easier to pack, especially when it comes to lifting and placing heavy kiln shelves. Moreover, they are usually very well insulated and are built robustly with welded steel cabinets that give them a long life.

Gas kilns

Gas kilns are more demanding in terms of installation and siting as they need flues or chimneys and require either a portable tank of propane gas (anything from 19kg/42lb upwards) to a permanent outside gas tank of 1 ton capacity. Most people use two 47kg (104lb) tanks on a double line to ensure the gas will not run out during a firing

or suffer from a pressure fall-off, which happens if gas is taken too fast from a single cylinder. Depending on the kiln size and the refractories used, one tank should give about three firings.

Modern gas kilns are clean and efficient and programmable, and will save you the expense of having to replace electric elements.

Propane-gas kilns are the most commonly used of the various fuel systems, having many of the advantages and none of the disadvantages of wood. The obvious attraction of gas is the facility it affords of being able to conduct reduction firings.

REDUCTION FIRING

Reduction firing is an art rather than a science and results can only be achieved by long experience trying out different permutations and getting to know your kiln. But, as we saw in Chapter 6, porcelain fired under reduction is possibly the most attractive and interesting of all ceramics. Reduction is a transformative process. Where, for instance, iron oxide gives brown in oxidation, it will give celadon and palest blue in reduction, while copper, which gives green in oxidation, will transform to pinks through to vibrant reds when reduced.

In a reduction firing oxygen is reduced in the chamber by limiting the amount of air which enters the burners, changing the flame from blue to yellow. By manipulating the vents at various times during the firing, the chamber is put under pressure, as less air is drawn around the burner. The atmosphere in the chamber will become overloaded and hazy with carbon monoxide, so that the clays and glazes being fired cannot find enough oxygen to ensure complete oxidation. In order to revert to carbon dioxide the kiln atmosphere will steal oxygen from the metal oxides in the clay and glaze, transforming their colours in the process.

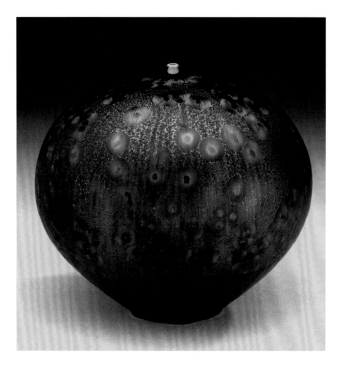

Hideaki Miyamura (Japan), *Bottle with Starry Night Glaze*, 2011. Reduction-fired to Cone 12, H: 20cm (8in) x D: 18cm (7in). *Photo: Dean Powell.*

Firings are usually kept oxidised up to 900–1000°C (1652–1832°F), then fired in light reduction up to top temperature or with alternate bouts of reduction and oxidation. Very heavy reduction is not recommended as this can cause bloating (see Chapter 8), while a very dense smoky atmosphere can also stain glazes. It will be noticed, too, that the reduction process somewhat slows the rate of temperature increase and will also cause the porcelain body to become slightly greyer.

It is important to keep a firing log, as with flame the exact degree of reduction is hard to quantify and results will vary. Perhaps this is why firings are always an adventure and beautiful results a triumph.

SALT OR VAPOUR GLAZING

Salt glazing or vapour glazing produces a mottled effect and interesting colour flashes on the wares. Damp salt or a saline mixture is introduced into the kiln at the last 80°C (144°F) of the firing. The salt then volatilises and combines with the steam to form a sodium alumina-silicate glaze on the wares. Silica in the clay body is fluxed by the sodium in the salt, producing a shiny surface. Additions of borax, or sodium nitrate, added to the salt give different effects as will the addition of colouring oxides. Wood ash is sometimes scattered on the shoulders of pots before firing to produce colour and textural variations. However, this technique is not suitable for electric kilns as walls and furniture become coated with salt vapour.

CRITERIA TO CONSIDER WHEN CHOOSING A KILN

A kiln is a semi-industrial or industrial machine and must be sited in a suitable environment, with all due consideration for safety. A concrete floor and proper light and ventilation are essentials. A qualified electrician is needed to install the wiring (domestic or three-phase) for an electric kiln, while a gas installer will be needed for a gas kiln. Beyond these points, the issues you need to consider when choosing your kiln are as follows:

1. What type of kiln is required, gas or electric?
2. What is the maximum temperature you intend to fire to? This has a bearing on which type of clays you can use.
3. Where is the kiln to be sited? Think about access.
4. Delivery. British kiln manufacturers no longer deliver or install their kilns themselves. Any kiln is likely to be delivered by a carrier, who will deposit it in the road, where you simply cannot leave it. You will therefore need to arrange help for moving it from the road to the final installation site.
5. Insurance. How will having a kiln affect your buildings insurance?
6. What size chamber do you need? Which is more important, height or diameter?
7. How well insulated is the kiln? Look for a kiln with a brick floor because considerable heat can radiate from the bottom of the kiln onto the floor. A poorly insulated kiln will lose a great deal of heat into the room and will thus be more expensive to run. It will also cool too fast, affecting the quality of the glazes.
8. Buy a kiln with a stand at least 30cm (12in) off the ground.
9. Install a kiln guard if children are anywhere near the studio.
10. On a top loader how heavy is the lid? Repeated lifting can be physically demanding.
11. In an electric kiln, are the elements well fitted into deep grooves in the brickwork? Elements will bag and stretch out of shallow grooves after repeated firings and will need to be replaced sooner than they might otherwise.

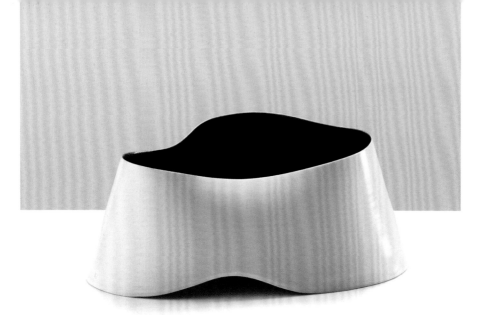

Sara Flynn (Ireland), *Arched Land Vessel*, 2012. Thrown and altered, H: 11cm (4¼in) x L: 20cm (8in) x D: 14cm (5½in). *Photo: courtesy of Erskine, Hall & Coe Ltd.*

I have always used kilns of less than 3 cu.ft capacity, which enables me to complete a series of work quickly rather than committing months of work to a large kiln. This also enables me to adapt and develop my designs seamlessly.

KILN SETTING

Kiln furniture

Prepare your kiln shelves carefully. Brush a thin liquid mix of alumina hydrate and a little china clay evenly onto the kiln shelf. Damping down the shelf first makes the mixture easier to brush. Dry completely before firing the kiln. An uneven build-up of batt wash can cause fine foot rings to warp. If the wash becomes too thin after a few firings a fine sprinkling of alumina can be sifted onto the shelf (**though wear a mask when doing this**).

Kiln furniture can be bought from suppliers in a wide variety of shapes to suit most needs. I find tubular shelf props safer to use than castellated props, but in any case always keep a good supply of all the various sizes (if possible).

The high shrinkage of porcelain during firing creates problems, and ways must be found to ensure that feet are free to contract evenly. Some makers like to support wares for glost firing with batt-washed 'biscuits' of clay, but I prefer to use ceramic fibre in sheet form to prevent warping. Gently press the piece down on the fibre to make an impression of the foot ring, cut to size (inner and outer circumferences) and glue to the bottom of the foot ring (I use honey kept for this purpose). Then the piece can be placed straight in the kiln without having to fiddle.

Nests of ceramic fibre or bisque rings filled with (reusable) batt wash can also be used to support fragile pieces, while glazed wares with no base can be suspended on

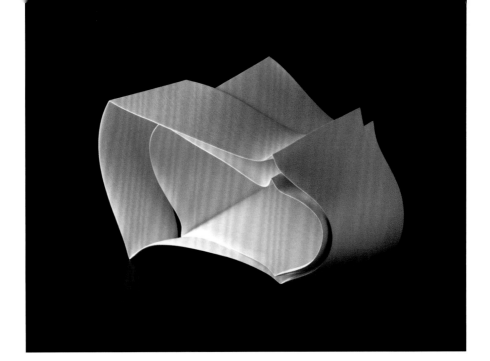

Shigekazu Nagae (Japan), *Forms in Succession #2*, 2011. Slipcast porcelain with glaze, H: 24cm (9½in) x W: 43.5cm (17¼in) x D: 31cm (12¼in). *Photo: courtesy of Yufuku Gallery, Tokyo.*

insulating rods planted vertically in a wad of clay. I have also made a 'washing line' from two tubular props drilled with holes at the top and threaded with nichrome wire from which to suspend small sculptural works.

Shigekazu Nagae suspends his slipcast porcelain sculptures from a heat-resistant metal rod in the kiln, allowing them to distort under their own weight.

Nuala O'Donovan prefers to do multiple firings of the same works, making adjustments after each firing.

Packing bisqueware

When packing porcelain there is no fundamental difference to placing stoneware, except that porcelain wares are potentially lighter and therefore easier to support.

Raw porcelain is very fragile and needs to be handled with great care. Never pack too many pieces on top of one another or you could lose the bottom ones; three fine bowls, one within the other, should be the maximum.

Always fire lids in place on their pots.

Placing wares in the kiln and then changing your mind is dangerous, so it is always a good idea to draw round your kiln shelf on a bench so that you can do a dummy run to plan the positioning and measure the various heights of your wares. Use a set square to make sure the vessels do not overhang the shelf and get too close to the elements.

Packing a glost kiln

The way in which a glost kiln is packed and fired determines the quality of the glazes. The density of the packing, the number and arrangement of shelves, and the speed and temperature of the firing and the cooling all have an effect. The thickness of both the

vessel walls and the glaze will also determine the finished characteristics. All this can only be learned by trial and error in your own particular circumstances.

Remember when placing wares to make sure there is at least 2.5cm (1in) clearance from the elements.

Once they have been glazed, wares are extremely vulnerable to being chipped or damaged and it is wise to get them packed as soon as possible. Double-check to make sure the foot rings or lid seatings are clear of any glaze.

Porcelain is very prone to warping unless vessels are accurately thrown and turned. An uneven foot ring will cause an open form to warp. The openings on teapots are notoriously difficult as the extra protuberances of spout and handle will pull the vessel off centre, causing warping. Wipe the glaze from galleries and seatings and paint with alumina before carefully reassembling and placing in the kiln.

Heat work and pyrometric cones

To achieve the optimum results with your glazes it is important to know your kiln and to work out your firing curves. Pack pots with similar glazes in the same firing or, having tested your kiln with cones placed on different shelves, get to know which shelves might be cooler. Most new kilns now have built-in pyrometers, but only cones will give you the true indication of the heat work and the glaze melt as the maturing temperature is approached. Where possible, cones are placed in twos or threes in front of a spyhole for observation. Once you have worked out your firing curves the cones can be dispensed with.

In order to avoid common glaze and body faults such as pinholing, bloating and dunting (see Chapter 8), it is necessary to control the heat work. It is advisable to have a slow climb, not above 100°C (180°F) per hour up to about 800°C (1472°F), at which point the kiln will be glowing red and any volatile gases will have been burnt off. The glazes will begin to sinter at about 1000°C (1832°F). At this stage it might be advisable to hold the heat and soak for half an hour before proceeding. It is often good practice to soak for half an hour at the maturing temperature, or just below, to smooth out any pinholes. The molten phase is from maturation down to about 900°C (1652°F). Glossy glazes can be cooled quickly, but matt and crystalline glazes benefit from slow cooling.

For some examples of typical firing curves see the chart opposite.

Glaze tests

There is always room for glaze tests in any firing. Apart from the colour and textural properties of a glaze, its viscosity should also be considered. Tiles should be fixed in a small wad of alumina-coated clay and fired in a vertical position.

Secondary to making glaze tiles, a promising new glaze can be made up in small quantities of about 500g (17½oz) and tested on small pots, leaving a good area of bare clay towards the foot in case of runs. There is no excuse for wrecking kiln shelves with pools of solidified glaze.

Firing curves									
Electric kiln: Oxidised firing curve for bisque									
Bisque or glost		Ramp 1				Ramp 2			Ramp 3
	Open or closed vent?	Speed deg. C (F)/ hour	To temp. deg. C (F)	Soak?	Open or closed vent?	Speed deg. C (F)/ hour	To deg. C (F)	Soak needed?	Soak needed or skip/end?
Bisque example no.1	Open	100 (180)	600 (1112) glowing red	No	Closed	100 (180)	1060 (1940)	30 mins	End
Bisque example no.2	Open	100 (180)	600 (1112)	30 mins	Closed	120 (198)	1000 (1832)	30 mins	End
Electric kiln: Oxidised firing curve for glost									
Glost example no.1	Open	100 (180)	600 (1112) glowing red	No	Closed	100 (180)	1260 (2300)	No	End
Glost example no.2	Open	100 (180)	600 (1112) glowing red	No	Closed	150 (270)	1250 (2282)	30 mins	End
Glost example no.3 for crystalline glaze	Open	100 (180)	600 (1112)	No	Closed	100 (180)	1280 (2336)	No	160 (288)/hour 1100 (2012) soak 4 hours off
Gas kiln: Reduction firing curve for glost									
Glost example no.1	Open	100 (180)	1000 (1832)	No	Alter burner settings and adjust damper	100 (180) reduction	1260 (2300)	No	End
Glost example no.2	Open	120 (216)	1000 (1832)	30 mins	Alter burner settings and adjust damper	150 (270) reduction	1250 (2282)	No	End
Glost example no.3	Open	100 (180)	1100 (2012)	No	Alter burner settings and adjust damper	100 (180) light reduction	1255 (2309)	Heavy reduction for 30 mins to 1260 (2300)	Skip and clamp down

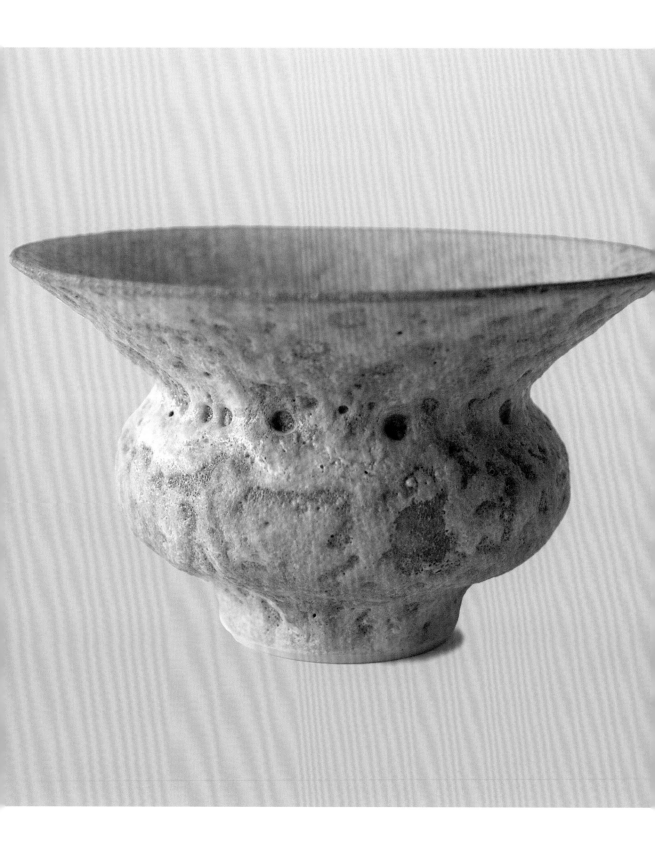

Faults and their remedies

FAULTS IN GREENWARE

Cracks

Cracks in general are caused by uneven walls or sections, or by drying too fast or too unevenly, or by trying to mend faults when too dry. It is also important to know your chosen clay body and to know what its limitations are.

S-shaped cracks

Cracks in the base of thrown wares (see Chapter 4).

Warping

If foot rings are too fine they can easily cause warping. Uneven throwing and turning is sure to result in warping, especially on open forms.

Remedies prior to firing

1. Paint foot rings with alumina so that they will not be held on the kiln shelf.
2. Cut a ring of ceramic-fibre mat to fit the foot ring, for the same purpose.

(For further details, see Chapter 7.)

GLAZE FAULTS

Factors to consider when puzzling over glaze faults are speed of firing and cooling, the maturation temperature of glazes, over- or underfiring, and composition of glazes.

Worn-out elements cause firings to slow, thus affecting the glaze.

Crazing

Porcelain bodies designed to be translucent, and therefore thin, have a low thermal expansion. The glaze will be under compression as it cools and so it might be necessary to increase the expansion of the glaze to avoid crazing. A thin, low expansion body with a thin, well-fluxed glaze is more likely have a good glaze fit and good craze resistance. When developing matt or satin matt glazes, it is better to choose a more plastic body.

Most stoneware glazes will craze to a greater or lesser extent when applied to porcelain. This is caused by a disparity between the rate of contraction (the coefficient of expansion) of the body compared with that of the glaze covering it.

LEFT: Vivienne Foley, *Blue/ grey Bell Bowl,* 1992. Silicon carbide slip with barium glaze. Max. H: 12cm (4¾in). *Photo: © VF.*

If the craze lines are very fine they may be difficult to see but will render wares unsuitable for food use. However, crazing may also be exaggerated to form a highly desirable effect in porcelain glazes.

Be aware that crazing can also develop over time.

Remedies

1. The addition of extra silica to the porcelain body, or the glaze, or both, can help to remedy crazing. Test in increments of 5%.
2. Increase the clay content.
3. Add a flux such as talc, though be aware that this will also change the quality of the glaze.
4. Replace soda or potash feldspar with a lower-expansion lithium feldspar.
5. Try lowering the maturing temperature.
6. The thicker a glaze is, the more likely it is to craze, so use a thinner application of glaze.

(For further details, see Chapter 7.)

Pinholing

Pinholing results from the bursting of gas bubbles from the body and the glaze during firing. It can also happen if there are contaminants in the body, such as bits of sponge or hair which get burned out at the bisque stage leaving a crater, or if the bisque or glost-firing curves are too rapid.

Pinholing can also occur if the glaze is underfired.

Remedies

1. Be more meticulous in clay preparation.
2. Go over bisqueware carefully with a diamond abrasive pad to smooth out any small craters.
3. Increase the maturing temperature slightly, though cautiously, as overfiring can also produce pinholing.

Pinholing.

4. Slow the firing curve and soak at maturing temperature for half an hour.

5. Slow the cooling ramp over the first 100°C (180°F).

6. Use wollastonite (calcium silicate), an alternative to whiting, as a source of lime in glazes, because there is less dissociation. (Materials which dissociate will form bubbles, some of which will burst and remain as pinholes as the glaze cools.)

7. The glaze slop may be too thick, so thin the slop somewhat if dipping, or spray a thinner layer. It is a matter of trial and error.

Bloating and blistering

Bloating and blistering occurs only in glazed wares. It is a particular problem of porcelain because of its dense vitrified body.

Bloating happens when a bubble is blown out from the body and then heals over as the glaze cools. If the bubble is ground down, a cavity will be found in the body with a black residue of unburnt volatiles. This can be the result of impurities such as fragments of iron in the body.

Blistering of the glaze can be due to impurities in the glaze or to overfiring. Glazes that are very heavily laden with oxides are prone to these problems.

Remedies

1. Do not place wares too close to the elements.

2. Raise the bisque temperature to 1060°C (1940°F). The body will still be porous. Fire at 100°C (180°F) per hour.

3. Soak at 1100°C (2012°F). Slow the firing curve between 1112°C (2033°F) and maturing temperature.

4. Soak for half an hour at maturing temperature and perhaps slow the first 100°C (180°F) of the down ramp.

5. To adjust the glazes, lower the maturing temperature by as much as 20°C (36°F) using nepheline syenite or wollastonite or a small addition of borax frit in place of Cornish stone or feldspar.

6. Don't fire too slowly. Aim for 11 to 12 hours maximum.

Bloating.
Right: Raised blowout.
Far right: Ground-down bloat showing carbonised deposit. *Photos:* © *VF.*

Dunting.

Dunting

Dunting is the failure of the body fabric caused by thermal shock. It is more likely to happen if there is already a mismatch between body and glaze. For instance, a thick crackle glaze applied to a very refractory porcelain body can result in the finished ware being weakened so much that it crumbles. Dunting can occur if the wares are fired and cooled too fast, or if the wares are taken from the kiln before they have cooled.

See Chapter 6, Glaze fit.

Remedies

1. When designing a glaze, first study 'glaze fit', (see also Chapter 6, p.116).

2. Pay attention to kiln setting. Place wares on stilts, make ceramic fibre pads, or make sure there is adequate batt wash on the shelves. If the shelves are worn I sieve a layer of alumina hydrate (like icing sugar) on the shelves making a very loose layer. This ensures there is no tension between the shelf and the foot rings.

3. Cool the kiln slowly on the down ramp. The larger and better insulated the kiln is, the slower to cooling.

4. Do not open the kiln before it reaches 50°C/122°F

See also Chapter 7, Kiln setting, pp.129–130.

Example of crawling on silicon carbide glaze.

Crawling

Crawling occurs when the bond between glaze and body is imperfect. The glaze gathers up during the glost firing, leaving a bare patch.

Remedies

1. Make sure the bisque ware is clean and free from dust before glazing.
2. When body and glaze are very thick, glost-fire at a slower rate than the bisque firing, up to 600°C (1112°F).
3. Make sure the glaze does not saturate the body when glazing.

Glaze-spraying is less likely to cause crawling than dipping as the glaze is deposited using less water content.

(For further details, see p.117, Making up a glaze recipe.)

For recommended further reading see *Ceramic Faults and Their Remedies* by Harry Fraser in the bibliography at the end of this book.

Appendix 1: Where to see historic and contemporary porcelain

A selection to visit or to explore online.
*includes contemporary collections

UK

London

Percival David Foundation, Room 95, The British Museum, Bloomsbury Street, London, WC1B 3DG. www.britishmuseum.org/

*The Victoria and Albert Museum, Cromwell Road, London, SW7 2RL. www.vam.ac.uk

*Contemporary Ceramics, 63 Great Russell St, London, WC1 3BF. www.cpaceramics.com

*Contemporary Applied Arts, 89 Southwark Street, London, SE1 0HX. www.caa.org.uk

Oxford

The Ashmolean Museum of Art and Archaeology, Beaumont Street, Oxford, OX1 2PH. www.ashmolean.org

Cambridge

The Fitzwilliam Museum, Trumping Street, Cambridge, CB2 1RB. www.fitzwilliam.cam.ac.uk

Bath

The Museum of East Asian Art, 12 Bennett Street, Bath, B1 2QL. www.meaa.org.uk

China

The Imperial Palace Museum, The Forbidden City, Beijing. www.dpm.org.cn

Shanghai Museum, People's Great Road 201, Shanghai. www.shanghaimuseum.net

Jingdezhen Ceramic History Museum, Jiangxi Province, Xishi District, Fengshushan Fengjing Qu.www.tcg.jdzol.net

Taiwan

National Palace Museum, no. 221, Sec. 2 Zhishan Road, Shilin Distrcit, Taipei City, 11143, Taiwan. www.npm.gov.tw

Hong Kong

Hong Kong Museum of Art, 10 Salisbury Road, Tsimhatsui, Kowloon. www.lcsd.gov.hk

Japan

*Yufuku Gallery. Annecy Aoyama 1F, 2-6-12 Minami-Aoyama, minato-ku, Tokyo, Japan 107-0062. www.yufuku.net

USA

Washington

Freer & Sackler Galleries of Art at the Smithsonian Institution (www.asia.si.edu):

Freer Gallery, Jefferson Drive at 1200 Independence Avenue Sw, Washington, DC 20013.

Freer & Sackler Gallery, 1050 Independence Avenue SW, Washington, DC, 20013

Arthur M. Sackler Gallery, 1050 Independence Avenue SW, Washington, DC 20560.

Boston

Museum of Fine Arts, 465 Huntingdon Avenue, Boston, MA 02115. www.mfa.org

San Francisco

Asian Art Museum, 200 Larkin Street, San Francisco, CA 94102. www.asianart.org

Italy

*International Museum of Ceramics in Faenza, Viale Baccarini n. 19, 48018 Faenza (RA). www.micfaenza.org/

Germany

Museum of Meissen®, Talstrasse 9, 01662 Meissen, Germany. www.meissen.com

France

National Museum of Porcelain Adrien Dubouché, Place Winston Churchill, Limoges. www.musee-adriendubouche.fr

Industry-related sites

Wheal Martyn China Clay Country Park, Carthew, St Austell, Cornwall, England, PL26 8XG. www.wheal-martyn.com

Appendix 2: Bibliography

Bloomfield, Linda, *Colour in Glazes* (London: A&C Black, 2012).

Brooks, Nick, *Mouldmaking and Casting* (Ramsbury, Wiltshire: The Crowood Press, 2008).

Butler, Curtis and Little, *Shunzhi Porcelain* (Alexandria, Virginia: Art Services Int., 2002).

Charlston, Robert J. (ed.), *World Ceramics* (London: Paul Hamlyn, 1968).

Foley, Vivienne, *Vivienne Foley Porcelain* (monograph) (London, Monograph, Moonmouse Creative Ltd, 2007).

Fraser, Harry, *Ceramic Faults and their Remedies* (London: A&C Black, 2nd Ed, 2005).

Fraser, Harry, *Glazes for the Craft Potter* (London: Sir Isaac Pitman & Sons. Ltd, 1973).

Grebanier, Joseph, *Chinese Stoneware Glazes* (New York: Sir Isaac Pitman & Sons, 1975).

Hess, Fred C., *Chemistry Made Simple* (London: W.H, Allen & Co. Ltd, 1967).

Jorg, C.J.A., *The Geldermalson: History and Porcelain* (Groningen: Kemper Publishers, 1986).

Lane, Peter, *Contemporary Studio Porcelain* (2nd edn) (London: A&C Black, 2003).

Leach, Bernard, *A Potter's Book* (London: Faber and Faber, 1976).

Medley, Margaret, *The Chinese Potter* (Oxford: Phaidon Press Ltd, 1980).

Nilsson, Jan-Erik, *The Letters of Père d'Entrecolles.* www.gotheborg.com © Transcribed from the English translation by William Burton, *Porcelain, Its Art and Manufacture* (London: B.T. Batsford, 1906).

Opgenhaffen, Jeanne, *Jeanne Opgenhaffen: Part 2* (monograph), (Brussels: Self-published, Royal library Brussels D/2013).

Petrie, Kevin, *Ceramic Transfer Printing* (London: A&C Black, 2011).

Pierson, Stacey, *Designs as Signs: Decoration and Chinese Ceramics* (London: Percival David Foundation, 2001).

Pierson, Stacey, *Earth, Fire and Water: Chinese Ceramic Technology* (London: Percival David Foundation, 1996).

Rhodes, Daniel, *Stoneware and Porcelain* (London: Pitman Publishing, 1959).

Scott, Rosemary E. (Ed) *Chinese Copper Red Wares* (London: Percival David Foundation, monograph series no. 3, 1992).

Wood, Nigel, *Chinese Glazes* (London: A&C Black, 1999).

Wood, Nigel, *Oriental Glazes* (London: Pitman/Watson-Guptill, 1978).

Yin Min, Thilo Rehren, Jianming Zhen. UCL Inst.of Archaeology. London: 'Melt Formation in lime-rich Proto-porcelain Glazes' *Journal of Archaeological Scienc*e, no:39 (2012) 2969-2983.

Yin, Min, Rehren, Thilo & Zhen, Jianming, 'The earliest high-fired glazed ceramics in China.' *Journal of Archaeological Scienc*, no: 38. (2011) 2352-2365.

Appendix 3: Featured artists

UK

AYLIEFF, FELICITY www.aylieff.com
DE WAAL, EDMUND www.edmunddewaal.com
DODDS, PAM www.studiopottery.co.uk
FOLEY, VIVIENNE www.viviennefoley.com
GOMEZ, TANYA www.tgceramics.co.uk
KEENAN, CHRIS www.chriskeenan.co.uk
RICHARDS, CHRISTINE-ANN www.christineannrichards.co.uk
SCOTT, PAUL www.cumbrianblues.com
SMITH, DANIEL www.danielsmith-ceramics.com
WOODROW, SOPHIE www.sophiewoodrow.co.uk

Ireland

FLYNN, MICHAEL www.michaelflynn.eu
FLYNN, SARA www.saraflynnceramic.com
LAMBE, FRANCES www.franceslambe.com
O'DONOVAN, NUALA www.nualaodonovan.com
WEST, KATHARINE www.oreillydesign.com

Germany

KAFKA, CORDULA www.kafkadesign.de

Belgium

OPGENHAFFEN, JEANNE www.opgenhaffen.com

Holland

BASTIAANSEN, PAULA www.paulabastiaansen.com

Poland

PATUSZYŃSKA, MONIKA www.patuszynska.art.pl

Norway

HANUM, SIDSEL www.hanum.no

USA

BYERS, SANDRA www.thebyersstudio.com
ERICKSON, MICHELLE www.michelleericksonceramics.com
FEIBLEMAN, DOROTHY www.dorothyfeibleman.com
HOADLEY, THOMAS www.thomashoadley.com

MAKINS, JAMES www.jamesmakins.yoworks.com
McCURDY, JENNIFER www.jennifermccurdy.com
TEILHET, JUSTIN www.jteilhetporcelain.com

Canada

BOYD, BILL www.billboydceramics.com

Australia

BIDDULPH, PETER www.ceramicdesign.org
SMITH, DEAN www.deansmithceramics.com

New Zealand

COLE, JEREMY www.jeremycole.net

Japan

MAETA, AKIHIRO c/o: www.yufuku.net
HAYASHI, SHIGEKI, c/o: www.yufuku.net
KAMEI, YOICHIRO c/o: www.yoichiro-kamei.net
MIYAMURA, HIDEAKI c/o: www.miyamurastudio.com
NAKAMURA, MAKIKO www.nakamuramakiko.com
NAGAE, SHIGEKAZU c/o: www.yufuku.net
FUKAMI, SUEHARU c/o: www.yufuku.net
TABUCHI, TARO (no website)
SAKURAI, YASUKO c/o: www.yufuku.net

China/Hong Kong

CHENG, CAROLINE c/o: www.potteryworkshop.com.cn
WONG, FIONA c/o: www.potteryworkshop.com.cn
XIAN, AH (no website)

Korea

JUCHEOL YUN c/o: www.kcdf.kr
KIM, DUCK HO c/o: www.gallerylvs.org
LEE, KA JIN c/o: www.gallerylvs.org
PARK, JUNG HONG c/o: www.gallerylvs.org

Brazil

NASCIMENTO, VALERIA www.valerianascimento.com

Appendix 4: Main suppliers

UK

Ferro (Great Britain) Ltd
(ceramic colours)
Nile St, Burslem,
Stoke-on-Trent,
Staffordshire ST6 2BQ.
www.ferro.com

Potclays Ltd
Brickkiln Lane, Etruria,
Stoke-on-Trent,
Staffordshire ST4 7BP.
www.potclays.co.uk

Potterycrafts
Campbell Rd,
Stoke-on-Trent,
Staffordshire ST4 4ET
www.potterycraft.co.uk

Scarva Pottery Supplies
Unit 20, Scarva Rd Ind. Est.,
Banbridge,
Co. Down,
Northern Ireland BT32 3QD.
www.scarvapottery.com

Valentine Clays Ltd
The Sliphouse,
18-20 Chell St, Hanley,
Stoke-on-Trent,
Staffordshire ST1 6BA.
www.valentineclays.co.uk

USA

Ferro Corporation
Global Headquarters (Info. only)
6060 Parkland Boulevard,
Mayfield Heights,
OH 44124.
www.ferro.com

Highwater Clays Inc.
600 Riverside Drive
Ashville,
NC 28801.
www.highwaterclays.com

Laguna Clay Co.
14400 Lomitas Avenue,
City of industry,
CA 91746.
www.lagunaclay.com

Standard Ceramic Supply Co.
PO Box 16240,
Pittsburgh,
PA 15242-0240.
www.standardceramic.com

Canada
Tucker's Pottery Supplies, Inc.
15 West Pearce St, Unit #7
Richmond Hill,
Ontario L4B 1H6.
www.tuckerspottery.com

Australia
Clayworks Australia,
6 Johnston Court,
Dandenong 3175,
Victoria.
www.clayworksaustralia.com

Appendix 5: Orton cone charts

Temperature equivalents (°F) for Orton Pyrometric Cones

	Self Supporting Cones						Large Cones				Small
	Regular			Iron Free			Regular		Iron Free		Regular
	Heating Rate °F/hour (last 200°F of firing)										
Cone	27	108	270	27	108	270	108	270	108	270	540
022		1087	1094				N/A	N/A			1166
021		1112	1143				N/A	N/A			1189
020		1159	1180				N/A	N/A			1231
019	1213	1252	1283				1249	1279			1333
018	1267	1319	1353				1314	1350			1386
017	1301	1360	1405				1357	1402			1443
016	1368	1422	1465				1416	1461			1517
015	1382	1456	1504				1450	1501			1549
014	1395	1485	1540				1485	1537			1598
013	1485	1539	1582				1539	1578			1616
012	1549	1582	1620				1576	1616			1652
011	1575	1607	1641				1603	1638			1679
010	1636	1657	1679	1600	1627	1639	1648	1675	1623	1636	1686
09	1665	1688	1706	1650	1686	1702	1683	1702	1683	1699	1751
08	1692	1728	1753	1695	1735	1755	1728	1749	1733	1751	1801
07	1764	1789	1809	1747	1780	1800	1783	1805	1778	1796	1846
06	1798	1828	1855	1776	1816	1828	1823	1852	1816	1825	1873
05½	1839	1859	1877	1814	1854	1870	1854	1873	1852	1868	1909
05	1870	1888	1911	1855	1899	1915	1886	1915	1890	1911	1944
04	1915	1945	1971	1909	1942	1956	1940	1958	1940	1953	2008
03	1960	1987	2019	1951	1990	1999	1987	2014	1989	1996	2068
02	1972	2016	2052	1983	2021	2039	2014	2048	2016	2035	2098
01	1999	2046	2080	2014	2053	2073	2043	2079	2052	2070	2152
1	2028	2079	2109	2046	2082	2098	2077	2109	2079	2095	2163
2	2034	2088	2127				2088	2124			2174
3	2039	2106	2138	2066	2109	2124	2106	2134	2104	2120	2185
4	2086	2124	2161				2120	2158			2208
5	2118	2167	2205				2163	2201			2230
5½	2133	2197	2237				2194	2233			N/A
6	2165	2232	2269				2228	2266			2291
7	2194	2262	2295				2259	2291			2307
8	2212	2280	2320				2277	2316			2372
9	2235	2300	2336				2295	2332			2403
10	2284	2345	2381				2340	2377			2426
11	2322	2361	2399				2359	2394			2437
12	2345	2383	2419				2379	2415			2471
13*	2389	2428	2458				2410	2455			N/A
14*	2464	2489	2523				2530	2491			N/A

Temperature equivalents (°C) for Orton Pyrometric Cones

Cone	Self Supporting Cones						Large Cones				Small
	Regular			Iron Free			Regular		Iron Free		Regular
	Heating Rate °C/hour (last 100°C of firing)										
	15	60	150	15	60	150	60	150	60	150	300
022		586	590				N/A	N/A			630
021		600	617				N/A	N/A			643
020		626	638				N/A	N/A			666
019	656	678	695				676	693			723
018	686	715	734				712	732			752
017	705	738	763				736	761			784
016	742	772	796				769	794			825
015	750	791	818				788	816			843
014	757	807	838				807	836			870
013	807	837	861				837	859			880
012	843	861	882				858	880			900
011	857	875	894				873	892			915
010	891	903	915	871	886	893	898	913	884	891	919
09	907	920	930	899	919	928	917	928	917	926	955
08	922	942	956	924	946	957	942	954	945	955	983
07	962	976	987	953	971	982	973	985	970	980	1008
06	981	998	1013	969	991	998	995	1011	991	996	1023
05½	1004	1015	1025	990	1012	1021	1012	1023	1011	1020	1043
05	1021	1031	1044	1013	1037	1046	1030	1046	1032	1044	1062
04	1046	1063	1077	1043	1061	1069	1060	1070	1060	1067	1098
03	1071	1086	1104	1066	1088	1093	1086	1101	1087	1091	1131
02	1078	1102	1122	1084	1105	1115	1101	1120	1102	1113	1148
01	1093	1119	1138	1101	1123	1134	1117	1137	1122	1132	1178
1	1109	1137	1154	1119	1139	1148	1136	1154	1137	1146	1184
2	1112	1142	1164				1142	1162			1190
3	1115	1152	1170	1130	1154	1162	1152	1168	1151	1160	1196
4	1141	1162	1183				1160	1181			1209
5	1159	1186	1207				1184	1205			1221
5½	1167	1203	1225				1201	1223			N/A
6	1185	1222	1243				1220	1241			1255
7	1201	1239	1257				1237	1255			1264
8	1211	1249	1271				1247	1269			1300
9	1224	1260	1280				1257	1278			1317
10	1251	1285	1305				1282	1303			1330
11	1272	1294	1315				1293	1312			1336
12	1285	1306	1326				1304	1324			1355
13*	1310	1331	1348				1321	1346			N/A
14*	1351	1365	1384				1388	1366			N/A

Temperature conversion chart

°C	°F	Kelvin K	Orton Cone		°C	°F	K	Cone
					920	1688	1193	09
0	32	273	N/A		930	1706	1203	
100	212	373	N/A		940	1724	1213	
200	392	473	N/A		950	1742	1223	08
300	572	573	N/A		960	1760	1233	
400	752	673	N/A		970	1778	1243	
500	932	773	N/A		980	1796	1253	07
600	1112	873	022		990	1814	1263	
610	1130	883			1000	1832	1273	06
620	1148	893			1010	1850	1283	
630	1166	903			1020	1868	1293	
640	1184	913			1030	1886	1303	
650	1202	923	020		1040	1904	1313	05
660	1220	933	019		1050	1922	1323	
670	1238	943			1060	1940	1333	04
680	1256	953			1070	1958	1343	
690	1274	963			1080	1976	1353	
700	1292	973			1090	1994	1363	03
710	1310	983			1100	2012	1373	
720	1328	993	018		1110	2030	1383	02
730	1346	1003			1120	2048	1393	
740	1364	1013			1130	2066	1403	01
750	1382	1023	017		1140	2084	1413	1
760	1400	1033			1150	2102	1423	2
770	1418	1043			1160	2120	1433	3
780	1436	1053	016		1170	2138	1443	
790	1454	1063			1180	2156	1453	4
800	1472	1073	015		1190	2174	1463	5
810	1490	1083			1200	2192	1473	
820	1508	1093	014		1210	2210	1483	
830	1526	1103			1220	2228	1493	
840	1544	1113			1230	2246	1503	6
850	1562	1123	013		1240	2264	1513	
860	1580	1133			1250	2282	1523	7
870	1598	1143	012		1260	2300	1533	8
880	1616	1153	011		1270	2318	1543	9
890	1634	1163			1280	2336	1553	
900	1652	1173			1290	2354	1563	10
910	1670	1183			1300	2372	1573	11

Index